Lost Restaurants
OF
EL PASO

EL PASO COUNTY HISTORICAL SOCIETY
EDITED BY ROBERT DIAZ

AMERICAN PALATE

Published by American Palate
A Division of The History Press
Charleston, SC
www.historypress.com

Copyright © 2021 by El Paso County Historical Society
All rights reserved

Front cover, top left: El Paso County Historical Society; *top center*: El Paso Public Library, Border Heritage Section; *top right*: El Paso Times; *bottom*: Mexicoenfotos.com.
Back cover: El Paso County Historical Society; *inset*: El Paso County Historical Society.

First published 2021

Manufactured in the United States

ISBN 9781467144872

Library of Congress Control Number: 2020948625

As we compiled this book, El Paso and Juárez experienced two horrific events. On August 3, 2019, a gunman opened fire at an east El Paso Walmart, killing twenty-three people and injuring an additional twenty-three. The following year, the borderland was one of the many areas struck by the COVID-19 pandemic. We do not yet know just how many thousands of families will experience hardship, illness and loss as a result.

To our beloved Paseños, both living and deceased, we dedicate this book as a token of the love and hospitality that we equate with our beautiful city. We will forever stand with you, and together we will remain El Paso Strong.

Contents

Contents

Acknowledgements

No scholarly work should be a solo feat, and surely this one was not. The El Paso County Historical Society (EPCHS) wishes to thank Claudia Rivers and Abbie Weiser at the University of Texas at El Paso, Special Collections Department, and Claudia Ramirez and Danny Gonzalez at the El Paso Public Library—Border Heritage Section for their knowledge and access to archival resources. It has been an honor to work with them on this project.

We also extend our deepest gratitude to Ben Gibson and the staff of The History Press for their unceasing guidance, support and patience. This work exists because of their assistance and professionalism.

We are thankful to the multitalented Sarah Dueñas, who always finds new ways of furthering EPCHS's mission of sharing and preserving El Paso's history.

Furthermore, we wish to express our great appreciation to Mike Daeuble and Jack Maxon for their invaluable contributions to the chapters on the Central Café and Jaxon's. It was through interviews with author Joe Lewels that the colorful history of their creative efforts as young entrepreneurs could be told. Mike and Jack went on to become two of El Paso's most successful restaurateurs. Jack Maxon has also been a tremendous supporter of EPCHS, and we thank him for his friendship. It was El Paso's great loss when Mike Daeuble died in November 2019, just one month after he was interviewed. We hope that the chapter to which he contributed is a fitting tribute to his life.

Last, but certainly not least, we are grateful to *El Paso Times* librarian and archivist Trish Long for her assistance. We could write a book of this size, if not larger, describing the ways she has dedicated her time and energy to the efforts of EPCHS. There is no doubt that the work we do as an organization is better because of her.

If we failed to thank someone who was integral to development of this book, we mean no disrespect and apologize profusely.

—El Paso County Historical Society

Editor's Acknowledgements

As the editor of this volume, it has been my pleasure to collaborate with the authors. I have come to know them by various means over the years, and I never cease to be amazed by their intelligence, talent and passion. As I read through the chapters, I found myself engaged, touched and shocked by the stories they told. Of course, I am not surprised that I reacted this way. I look up to these authors, and I try to model my work after their own. I thank them for their contributions to *The Lost Restaurants of El Paso*.

I also cannot thank my partner, Christina, enough for putting up with the long hours and offering keen insights as I put this volume together.

—Robert Diaz

Introduction
El Paso's Culinary Heritage

SUSAN STANFIELD

El Paso was a crossroads long before it was a borderland. For hundreds of years prior to Spanish conquest, indigenous peoples interacted with one another throughout present-day northern Mexico and the American Southwest, regularly moving through *El Paso Del Norte* (the Pass of the North—the area encompassing present-day El Paso County, Texas, and Juárez, Mexico). After the arrival of Spanish colonials in the 1500s, Paso Del Norte became a hub of commerce along *El Camino Real de Tierra Adentro* (the Royal Road of the Interior) that connected Mexico City to Santa Fe, New Mexico. In 1848, following the bloody U.S.-Mexico War, the Treaty of Guadalupe Hidalgo divided Paso Del Norte along the Rio Grande. The area presently known as El Paso, Texas, became part of the United States. What is now known as Ciudad Juárez, Chihuahua, remained part of Mexico. In 1850, the U.S. government claimed: "The Northern limit of Texas and the Southern limit of New Mexico and the Indian Territory, is to be a line drawn from El Paso to a parallel a little more than 34°. This would give Texas enough territory for four states."[1] El Paso was at the center of each of these geographic designations. Though the City of El Paso, Texas, was not incorporated until 1873, the area had been an international cultural crossroads long before that time.

Indeed, the various peoples who inhabited the area for thousands of years created distinct food cultures and foodways. As previously mentioned, trade existed among the region's indigenous peoples for centuries before Europeans

arrived in the Americas. And between the sixteenth and nineteenth centuries, as a result of Spanish and, later, American colonization, commerce brought many more people through Paso Del Norte, creating an exchange of foods and recipes among those of different cultures and regions. Nineteenth-century diarist Susan Shelby Magoffin traveled *Down the Santa Fé Trail and Into Mexico* from 1846 to 1847. In her diary, she provided lengthy descriptions of food, kitchens and social practices that she encountered on the trail, offering strong reactions to the new cuisines she tried. Not far from El Paso, she described the meals served in a house where she boarded for a short time. "Our dishes are all Mexican, but good ones, some are delightful: their meats are all boiled, the healthiest way of preparing them, and in most instances are cooked with vegetables, which are onions, cabbage and tomatoes; with the addition of apples and grapes; the courses for dinner are four, one dish at a time; for breakfast two, ending always with beans."[2]

In 1881, railroads arrived in El Paso, and the resulting population boom increased the need for restaurants to feed those in transit. In addition, the surging population and economy made the success of restaurants more likely with a viable local clientele. The 1888 city directory demonstrates the growth of restaurants in El Paso. Railroads brought Chinese immigrants to the region, several later opening Chinese restaurants downtown. At least five restaurants each provided employment for several individuals. Other restaurants opened that appear to have been separate from hotels and the railroad station, including the Cuckoo and Boss Restaurant and the Delmonico, which likely took its name from the famous New York City restaurant that opened in the early nineteenth century.[3] Two lunch carts were included in the directory, as well as many restaurants affiliated with hotels.

By 1898, El Paso had grown large enough to include various recreational, benevolent and self-help organizations, including the Ladies' Auxiliary for the YMCA. This group produced the first known community cookbook in El Paso. Beyond the typical late nineteenth-century recipes, this cookbook also includes a section of "Dishes for the Sick" and a "Mexican Department." With over fifty entries, the Mexican Department contains some of the first versions of the recipes published in English. This section offers eight different recipes for chile sauce provided by Mrs. Cooper, Mrs. Hixon, Mrs. K., Mrs. Patterson, D.W.S., Mrs. Marvin, Mrs. Blacker and H. Kayser.[4] The cookbook also highlights U.S. regional dishes from the South, New England and the Midwest, as well as Irish, Dutch, French and German recipes (German dishes are by far the most widely listed). The variety of recipes that the women of El Paso chose to publicly share in this cookbook further

BROCK & JONES Lands

126　　　EL PASO DIRECTORY CO.'S

Restaurants.

Benegras Placida, San Antonio bet s Oregon and Utah sts.
Cerehino John 209 El Paso st.
Chou Mar, Chinese, Windsor restaurant 409 El Paso st.
Dan Eye, 107 e Overland st.
Delmonico, G. Lemaire prop, 320 El Paso st.
Early Hannah Mrs., cor n Utah and e Main sts.
Hobbs Maggie C., cor El Paso and e Overland sts.
King Sherman W., 103 e Overland st.
Link Chop House. 218 El Paso st.
St. Charles, Center block cor El Paso and San Francisco sts.
St. George, Miss Mildred Burke props., San Antonio bet s Oregon and Utah sts.
Toy Mar, Chinaman, Grand 223 San Antonio st.
Vienna, El Paso bet e Overland and Second sts.
Wau Lu, Chinese restaurant cor s Oregon and San Antonio st.
Wing Jim, 211 e Main st.

Ruling.

TIMES PUBLISHING CO., 73 Oregon at.

Saddlery and Harness.

ALEXANDER JAMES, 502 El Paso st, r cor Fourth and Hills sts.
ANDREWS & HILLS, cor El Paso and Second sts.

Saloons.

Baccus, Butterworth & McLean, props., 107 San Antonio st.
Begemann C. F. W., 322 El Paso st.
Blevins & Saunders, cor El Paso and e Overland sts.
Brennan Patrick, e Main bet Oregon and Utah sts.
Fashion, Dan Morris & Co., props., 104 San Antonio st.
Fellows & Gordon, Palace, 205 San Antonio st.
Kleupfer & Co., 106 Lane block.
Gem, El Paso bet San Antonio and e Overland sts., John J. Taylor prop.
Grand Central hotel bar, Sam Ecker prop.
HOWARD & DUNKLE, Parlor, cor El Paso and San Antonio st
OPHIR, McPike & Young props., 106 El Paso st.
RANCH, 211 El Paso st, Philip Smith prop.
Ryan Simon, mint 207 El Paso st.
THE BOSS, H. R. Hillebrand prop, s e cor Overland and El Paso st.
The Chief, Paul Keating prop., El Paso bet e Overland and Second sts.
Vault, Shryock & Buoy props., 103 San Antonio st.
Woods John. (col), 218 s Oregon st.

El Paso City Directory, 1888, El Paso Directory Company. *El Paso County Historical Society*.

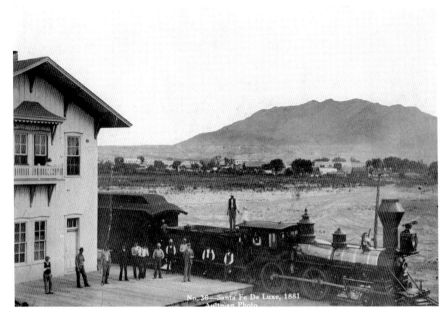

With the arrival of railroads in El Paso in May 1881, the small town blossomed into a thriving city over the next several decades. *El Paso County Historical Society.*

demonstrates the diversity of food appreciated in the city. As El Paso grew into a thriving international metropolis throughout the twentieth century, the regional cuisine reflected the myriad peoples living in the area. Mexican dishes, soul food, Asian, fusion: locals and visitors alike relished the multitude of restaurants and meals served in the borderland.

To fully understand the culinary history of El Paso, however, one must first grasp the city's inseparable connection with Ciudad Juárez, Mexico. Both cities forge an international metropolis (which will be referred to in this book as Paso Del Norte) of over two million people and share history, culture and economies. Many *Juarenses* (people living in Juárez) commute over the international bridges to shop, study, work or visit family in El Paso. Many El Pasoans traverse the bridges to do the same across the border. Though the Treaty of Guadalupe Hidaglo (1848) established the Rio Grande as part of the international boundary between the United States and Mexico, people easily crossed back and forth between El Paso and Juárez well into the twentieth century. The rapid militarization of the border has not stopped this movement. It is not an exaggeration to say that neither city would fare very well without the other. They truly are sister cities. As such, this book not only highlights the lost restaurants of El Paso

El Paso Street, looking northeast toward the Franklin Mountains that cut through El Paso, circa 1883. *El Paso County Historical Society.*

but also offers readers a small taste of the lost restaurants of Juárez to provide examples of this bond.

The history of El Paso's lost restaurants is one lens through which to view the history of the Paso Del Norte borderland. The restaurants discussed in the following chapters offered more than meals to their patrons. They provided a sense of community, avenues for cultural exchange and places to create lasting memories. They were spawned and sustained by the imaginations and tenacity of their owners, chefs and staffs. Some of these people had deep roots in the region, and some were newcomers who made the borderland home. The restaurants also reflect the history of this region during times of economic boom and decline. Furthermore, they underscore the culinary tastes of *paseños* across generations.[5]

This book is divided into three parts, demonstrating that the history of El Paso's lost restaurants is also intertwined with notions of space and geography. Part I describes the evolution of the Paso Del Norte borderland and the restaurants that emerged as a result. Part II redirects the focus to El Paso proper. In the first half of the twentieth century, El Paso was a bustling southwestern American city with an emergent downtown. By the end of the century, many businesses had moved into the suburbs, leaving the city's core a shell of its former glory. This chapter illustrates the movement patterns of El Pasoans, the consequent business cycles that resulted and the memories and nostalgia arising from the closure of once booming restaurants. Part III explores the impact of international influences on

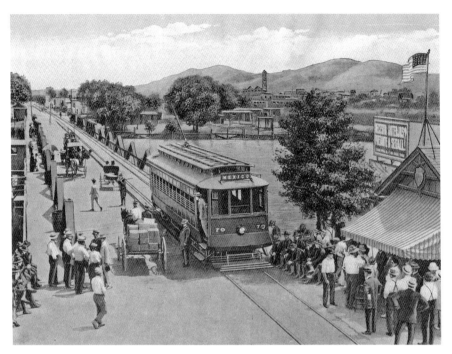

Electric streetcars took people across the international bridge into Juárez and El Paso between 1902 and 1973. *El Paso County Historical Society.*

local cuisine and the sense of home away from home that patrons of El Paso's restaurants often feel. Unfortunately, the list of lost restaurants that are memorable to El Pasoans is too comprehensive to fully include in this book. Perhaps your favorite is not discussed in the following chapters. For that, we sincerely apologize. Ultimately, our selections showcase some of the favorite restaurants of longtime residents but also tell a history of the borderland through the lens of El Paso's former culinary offerings.

We hope you enjoy reading about the lost restaurants of El Paso.

PART I
EL PASO AND JUÁREZ
Inseparable Sister Cities

1

A Taste of the Evolving U.S.-Mexico Border

Border-Making, Cuisine and La Hacienda Café

ROBERT DIAZ

The building is difficult to find. In fact, many locals do not know how to get there anymore. La Hacienda Café (1720 W. Paisano Drive), a thriving establishment during much of the twentieth century, evokes the memories of countless El Pasoans who remember drinking cheap, ice cold beer and enjoying delectable Mexican food only a stone's throw away from the international boundary between the United States and Mexico. But if you asked one of them at random how to get to the historic adobe structure once home to the restaurant, few El Pasoans would be able to give you reliable directions, even with the help of GPS. The building is vacant, wedged between an overgrowth of shrubs, a network of highways and an iron fence constantly monitored by the United States Border Patrol. It is all but hidden and detached from the rest of the city. In some ways, however, it is fitting that the old adobe structure is centered among these artifacts of our time. Completed over 170 years ago, the building is the product of centuries of international conquest and located on what is arguably one of the most historic patches of land in El Paso, Texas. Though it is now overshadowed by the infrastructure just noted, one could say it continues to witness the evolution of the borderland.

The story of the borderland and the story of La Hacienda Café parallel each other. Indeed, both inform the histories of Spanish and American conquest, the emergence of thriving businesses in mid-sized towns during

the mid-twentieth century and the neglect of historic appreciation and preservation rampant in El Paso today. The following is a brief history of La Hacienda Café, which in turn mirrors the history of the borderland. It is a story of indigenous peoples, Spaniards, Americans, Mexicans and Mexican Americans engaging with one another in ways both violent and convivial. Food is another character in this story. It has always been a crucial element of survival in the borderland. Indeed, visitors to the region between the seventeenth and nineteenth centuries frequently remarked on the abundance of crops growing along the banks of the Rio Grande, which flows through the center of this desert valley. This chapter is also a story of memory. Even if the ability to find the physical location of La Hacienda Café has all but faded, the restaurant is remembered fondly. La Hacienda was more than a place to enjoy a good meal. It was the site of civic engagement and entertainment. It evoked a rich and diverse history and, because of its proximity to the international boundary, was a constant reminder of the interconnectedness of El Paso and Juárez. Today, El Pasoans may have difficulty locating La Hacienda's physical location. But it is certainly not difficult for *paseños* to locate La Hacienda Café in their memories and in themselves.

THE CONQUEST OF EL PASO DEL NORTE

Before proceeding, a brief history of Spanish and U.S. imperialism, as it relates to the borderland, is necessary. Spanish colonialism arrived in the borderland in the 1500s. After decades of small incursions into the region by Spanish colonials, in May 1598, Don Juan de Oñate and a caravan of four hundred people who had begun their trek in Central Mexico, forded the Rio Grande approximately a mile northwest of present-day downtown El Paso, Texas. Here the river followed through a passable valley bisecting two rugged mountain ranges. Perhaps taking a cue from these geographic features, Oñate called the area *El Paso Del Norte* (the Pass of the North). Only several days earlier, Oñate had claimed the lands upon which he was about to step foot for the Spanish Crown, establishing his authority as governor of New Mexico. It is important to note that indigenous people navigated Oñate and his caravan at multiple points during the journey. Indeed, indigenous peoples had inhabited the borderland for hundreds of years, if not over a thousand, before colonials laid claim to the region.

Oñate's conquest was one element in the pervasive Spanish colonial project that spanned the Atlantic and Pacific Oceans, the Caribbean, vast areas of North and South America and parts of Southeast Asia. Over the next three hundred years of intense periods of conflict and cooperation, the town of El Paso Del Norte (present-day Ciudad Juárez) flourished into a bustling trading hub along *El Camino Real de Tierra Adentro* (the Royal Road of the Interior), which connecting Mexico City to Santa Fe, New Mexico. Other settlements dotted the landscape along the banks of the Rio Grande: San Elizario, Socorro, Ysleta, Senecú and San Lorenzo. Together, these settlements, along with El Paso Del Norte, created the region recognized as Paso Del Norte.[6]

El Paso's culinary history developed, in part, as a result of the interactions between indigenous peoples and Spanish colonials. To the north of Paso Del Norte, "The Pueblo Indians of New Mexico, when the Europeans first met them, were agriculturists, living in established villages and tending their fields of crops. Every kind of corn was grown by the natives of the New World; it was their main crop."[7] Conversely, colonials brought with them Old World animals such as cows, pigs and horses, along with fruits such as apples and grapes. In 1766, Nicolas LaFora, a Spanish colonial surveying the area, wrote: "All this stretch of land is very well cultivated, producing everything that is planted, particularly very good grapes which are in no way inferior to those of Spain. These are many European fruits which are produced in such abundance that they are allowed to rot on the trees. The inhabitants make passable wine and better brandy, but at times they do not harvest enough maize for their support, because the ground is devoted to vines and other crops."[8] The area's climate, when cooperative, and proximity to the Rio Grande provided a nurturing environment for the borderland's agricultural yields. Furthermore, indigenous peoples and Spanish colonials developed technology to improve output, the most important of which may have been *acequias* (irrigation ditches), allowing them to use the water of Rio Grande to cultivate crops.

In 1821, Spain's three-century rule over Mexico ended following a violent revolution. For the next twenty-five years, the Mexican government struggled to establish firm control over its republic and had even more difficulty securing its northern provinces, of which Paso Del Norte was part. To manage the situation, the government invited individuals from the United States to settle in Texas (which was also a northern province of Mexico), hoping that these new residents would populate this desolate region and pledge allegiance to Mexico. The settlers had other ideas. Many

of them, hoping to extend slavery's reach, launched a rebellion against Mexico, declaring independence in 1836. Nine years later, the United States annexed Texas, claiming the Rio Grande as the international boundary. Mexico never recognized Texas's claim to independence and certainly did not concede that the boundary extended all the way to the Rio Grande. In April 1846, this dispute erupted in violence along the river, U.S. president James K. Polk claiming that "American blood had been shed on American soil." Shortly thereafter, the United States declared war on Mexico. The war was waged on fronts spanning from California to the Gulf of Mexico. Soldiers from Missouri marched along the Santa Fe Trail, down El Camino Real de Tierra Adentro, into El Paso Del Norte on their way to the interior of Chihuahua. After nearly two years of fighting and the deaths of approximately forty-four thousand troops from both countries combined, in February 1848, representatives from the United States and Mexico signed the Treaty of Guadalupe Hidalgo, bringing combat to an end and legally establishing the Rio Grande as the international boundary from the Gulf of Mexico to El Paso Del Norte. As a result of a war of conquest, political negotiations, legal language and illustrations drawn on maps, the Paso Del Norte region—which included the town of El Paso Del Norte and the other settlements lining the riverbanks—was split in two.[9]

A CENTER OF SUSTENANCE

In terms of the borderland's culinary history, several developments emerged from this geopolitical division. For one, the borderland remained an agricultural hub. Anson Mills, a newcomer to the region, stated in 1858: "After seven days' and nights' travel, when I arrived at the bluffs overlooking the valley of the Rio Grande, I thought it was the most pleasant sight I had ever seen. When we drove into the town, [it] consisted of a ranch of some hundred and fifty-acres in cultivation in beautiful grape, apple, apricot, pear, and peach orchards, watermelon, grain wheat and corn..."[10] Mills's description parallels LaFora's illustration of the borderland as an Edenlike valley in which visitors and residents alike could obtain sustenance. Indeed, many visitors to the region between the seventeenth and nineteenth centuries described it similarly.[11] (It should be noted, though, that while lush agricultural scenes dotted the land along the Rio Grande, much of Paso Del Norte consisted of rugged desert.)

Second, an influx of Americans, many of them veterans of the U.S.-Mexico War, decided to settle in El Paso, Texas.[12] Simeon Hart, for instance, established *El Molino*, an estate consisting of a gristmill and home, a short distance from the same river ford that indigenous people and Spanish colonials had used to cross the Rio Grande for centuries. Using hydropower from the Rio Grande, Hart supplied flour to U.S. Army posts in New Mexico and Texas.[13] Next to the mill, Hart built a large hacienda-style house out of adobe and sycamore branches for his wife, Jesusita Siquieros, and their children.[14]

El Molino became a thriving settlement in American El Paso prior to the U.S. Civil War. Situated along the banks of the river, framed by the picturesque mountains surrounding the rough, desert landscape, the estate evoked an idyllic image in the minds of visitors. Judge W.W.H. Davis, after a visit to El Paso in 1857, wrote: "El Molino...the residence of Judge Hart, is rather romantically situated upon the east bank of Del Norte, three miles above the Mexican town of El Paso, and a short distance below where the river forces its passage through the mountains. The house is built in the Mexican style, is large and convenient, and within were found ever luxury and comfort of home."[15] *El Molino* was essentially a small town within the evolving boundaries of El Paso County, Texas. Harriot Howze Jones explains: "Molino—the hacienda and the mill—was the center of a small community. The 1860 census listed 49 residents on the estate of some

Simeon Hart's mill supplied flour to U.S Army posts throughout Texas and New Mexico. *El Paso County Historical Society*.

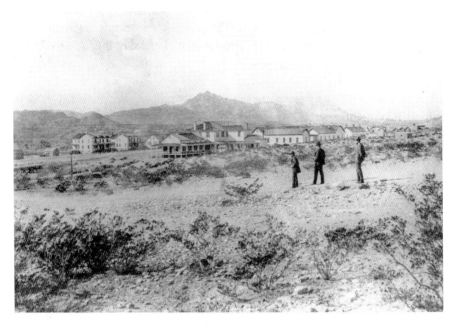

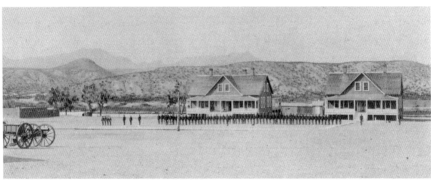

Top: Three men gaze at Fort Bliss near the Hart homestead, circa 1893. *El Paso County Historical Society.*

Bottom: Between the 1870s and early 1890s, Fort Bliss was located on land previously occupied by Hart's Mill (also known as *El Molino*). *El Paso County Historical Society.*

600 acres. These included Hart and his family, Charles Merritt and Oscar Blakesley, millers; two negro slaves, with their children and grandchildren, and several families of Mexican servants and laborers."[16] By 1860, the estate was worth approximately $350,000.[17]

The Hart family lost much of their estate during the Civil War. Hart, a Confederate sympathizer, fled to Mexico once Union forces claimed

victory in the area. The family returned to their home following the war and reclaimed some of their property. Nevertheless, *El Molino* failed to attain the success it amassed in the 1850s. Jesusita Siquieros died in 1873, followed by Hart a year later. Their oldest son, Juan, then became manager of the estate. Fort Bliss leased some of the land from Juan, on which it built officers' quarters and other structures. By 1895, the mill had shut down completely and Fort Bliss had moved. Nevertheless, the hacienda-style home remained occupied by various members of the Hart family until the 1930s.[18]

FINE FOODS AT LA HACIENDA CAFÉ

History had all but left the Hart family estate behind just before the dawn of World War II. After it ceased to be used as a residence, it fell into disrepair. Enriqueta López, co-proprietor of La Hacienda Café, recalled first entering the vacant structure in 1933: "When we entered the middle section of the building, bats flew out of the fireplace and there was a particular odor. My mother and I said we would not live there and also decided that the place was too large for our small family."[19] Though the Harts' legacy remained formidable in El Paso, the artifacts of that legacy were quickly deteriorating. Nevertheless, the Lopez family would soon inhabit the large structure, contributing to the culinary history rife within its walls.

Like many El Pasoans, Enriqueta López (née Rubio) was the product of centuries of colonization. Born in 1908 in El Paso's First Ward, a predominately Mexican/Mexican American community, she experienced the segregated social structure characteristic of the city at the turn of the century. As a child, López learned from her mother, Virginia, a police officer, the value of civic engagement. Politically active, Virginia organized voting drives and taught people how to read so they could vote. López explained: "We would call at each house. My mother said things like, 'Whom are you going to vote for?' 'Do you know how to vote?'…People would ask, 'How can I vote?' then my mother would tell them, 'Take note of the letters so you can learn to read. Study for a whole week; study these letters.' No one knew how to read in those days.…My mother would spell out each word, accenting the names of the letters."[20]

Looking back, one might say that Lopez's life was shaped by Paso Del Norte's culinary traditions. Her aunt, Pilar Little, taught Lopez's mother

how to cook when she was a young girl. (Little was born in Paso Del Norte in 1806, when the region was still claimed by Spain.)[21] "One of our family friends...was George Griggs of Dona Ana County in New Mexico," López recounted in 1979. Griggs was a member of a prominent New Mexico family that established a small empire of restaurants in El Paso, New Mexico, and California (see chapter 11). In 1930, she met Alfonso López, a restaurant owner in Juárez, and they married in November 1931. She recalled: "My husband's musicians [from the restaurant] would come to our house early in the evening because they went home early since the International Bridge closed at 10 p.m. I would play piano with them, my mother would make tamales, and we would have a happy time with beautiful music, good food, and good company."[22] López assisted her husband at the restaurant, and they soon expanded. They opened another location in El Paso near the American Smelter and Refining Company (ASARCO), along the international boundary.

Initially, the Lópezes shirked the idea of living in the Hart home. In 1933, James J. Watts, former water commissioner and a friend of the López family who had come into possession of the house, asked Virginia if she, her daughter and son-in-law were interested in living there. Apart from the ghastly sight of bats and the unpleasant odor inside, the Lópezes also thought that the house was far too large for their humble family. Indeed, the size of the house could seem daunting at first glance. It has been described as a "large one-story house...of plastered adobe [with] a flat roof, with a parapet. There is a wide arched gallery or porch across the front and one side. There are 10 or 12 rooms opening from a *Salon Grande* which runs the depth of the house with a massive fireplace at the end, flanked by two very large windows. The ceilings are 15 feet high. Several of the rooms opening from the great hall have fireplaces."[23]

Eventually, the family changed their mind. Several years following their initial acquaintance with the Hart homestead, a fire destroyed the restaurant that the Lópezes owned near ASARCO. They reached out to Watts and asked him if they could open a new café at the former Hart home, dilapidated as it was. Watts agreed. Time had continued to batter the property, which was "further destroyed by the weather, tramps, and people wanted by the police and others."[24] Nevertheless, the Lopez's had found the place where they would establish one of the region's most memorable and lasting restaurants. Enriqueta was the brains behind its branding. Recognizing that the building looked like a Mexican-style hacienda, she named the new establishment La Hacienda Café.

The restaurant received acclaim from critics and patrons almost instantly. It was marketed as the place "where you can bring the entire family and enjoy Fine Mexican Food" and for "Meals Mexican Style, Dancing—Beer on Tap." The *El Paso Times* printed in September 1942, "If you like fine Mexican food, if you like to eat in an atmosphere of rest and quiet, La Hacienda Café, at the foot of Sunset Heights viaduct, just off alternate Highway U.S. 80 offers an ideal place."[25] A well-curated bar offering beer on tap and fine wines was located near the dining room, and the chef specialized in making Mexican dishes.[26] Alfonso López was astonished by the number of Fort Bliss soldiers who frequented the establishment. Though Fort Bliss had occupied the land adjacent to the Hart homestead for over a decade in the late nineteenth century, the military post had long since moved to east El Paso, approximately ten miles away. In 1943, López attributed part of the allure to the bus that took soldiers directly to the restaurant, explaining, "During these times when gasoline and tires must be conserved, it is nice to know that you can reach a place for a genuine Mexican meal without having to use the car or take a long disagreeable walk to reach your destination."[27]

In several ways, La Hacienda Café renewed the culinary history that began at Hart's *molino* and home. The café blended hearty, flavorful meals with a colorful, historic ambiance. For years, patrons lauded the eclectic dishes on the menu. Though known primarily as a Mexican restaurant, the Lópezes also served T-bone, sirloin and rib steaks; steak *a la tampiquena* (steak smothered in chile con queso); fried chicken; chicken-fried steaks; pork chops; breaded veal cutlets; fried fish; spaghetti; sandwiches apart from the traditional servings of caldillo; chiles rellenos; red and green enchiladas; tamales; and chile con queso.[28] The former Hart family home also became home to the López family. In 1979, Harriot Howze Jones wrote, "Half of the house, which includes the Salon Grande, and five other rooms are occupied by Mr. and Mrs. Lopez and their daughter and granddaughter.... The gallery has been glassed in and dining tables placed there, also several other rooms for dining, and a bar and modern kitchen for the café have been added. The place is well patronized, and it is intriguing to have your *enchiladas* and *chile con carne* served in colorful surroundings in the oldest home in El Paso."[29]

As delectable as La Hacienda Café's dishes were, the restaurant did much more than serve food. For years, it promoted civic engagement, theater productions and entertainment. Varied organizations such as the Press Club of El Paso, Toastmasters, the League of United Latin American Citizens, the El Paso Chapter of the Political Association of Spanish Speaking

Organizations, community groups supporting the election of John F. Kennedy and Lyndon Johnson and the Texas Western College (TWC, now the University of Texas at El Paso) Faculty Women's Club Newcomers hosted meetings and dinners at La Hacienda Café.[30] The Mexican consul general in El Paso and his staff held a dinner at the restaurant for local members of the press.[31] Furthermore, tryouts for *Lost Demon Found*, a melodrama written by a TWC student, were held at La Hacienda, and the play was performed outside of the café on a platform built for the event.[32] Other plays, produced by various troupes including one dubbed La Hacienda Players, performed for audiences on warm summer and fall nights throughout the 1950s and '60s.[33] Bullfighting tryouts, films, and clubs provided patrons with even more entertainment.[34]

In short, La Hacienda Café's customers forged lasting memories at the restaurant, which satiated their appetites for good food, drinks and entertainment against the backdrop of vibrant borderland scenery. Patrons loved the food, but just as importantly, they loved the surroundings. There was nothing quite like being "in the adobe building...dating to 1851. It blends into the landscape of salt cedars, dusty river bed and view of the

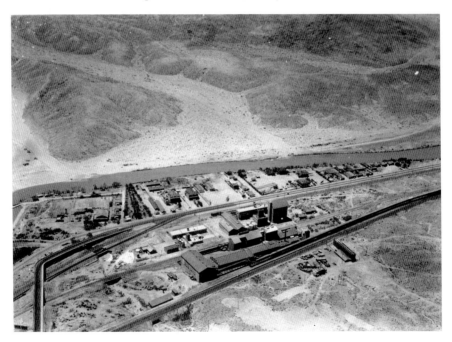

Bird's-eye view of La Hacienda Café (*far-left center*), Rio Grande (*center*) and Juárez, Mexico (*top*). *El Paso County Historical Society.*

outskirts of Juarez just opposite."[35] Some former diners remember visiting the café because it had the coldest and cheapest beer in town. Others recall rendezvous with friends after classes at UTEP, where they would "go down and get two or three pitchers of beer and sit there and drink beer for a while and compare notes or cheat."[36] Former city representative Jan Sumrall once noted: "It's got the flavor of El Paso....Anytime I had visitors, that was the first place I would take them."[37]

EL PASO DEL CONCRETO

La Hacienda Café closed its doors in 1998. Enriqueta López died in 1981, followed by Alfonso López several years later. In 1981, Mary Kime and her husband, Lynn R. Kime, purchased the restaurant and managed it for several years. By the turn of the century, however, upkeep and profits became unsustainable. The shutdown of this infamous establishment shocked El Pasoans, but hopefuls, like local historian Leon Metz, believed that the building could be used as a museum to showcase the region's history.[38]

The land formerly occupied by Hart's Mill, now designated as Oñate's Crossing, is enclosed by shrubs, the international boundary fence and highways, July 2020. *Robert Díaz.*

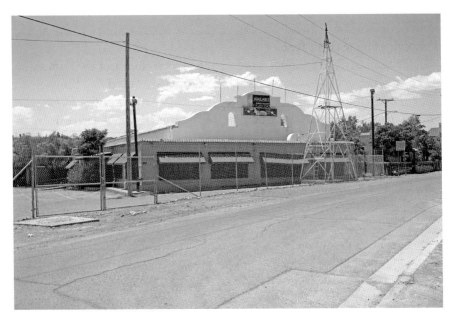

The building previously occupied by the Hart family and La Hacienda Café sits vacant near the international boundary, July 2020. *Robert Diaz.*

La Hacienda visitors would enter from the southern end of the building, seen in this photograph. Note the highway overpass to the east, July 2020. *Robert Diaz.*

Metz's hopes, though well-intentioned, did not align with the political and economic climate of El Paso.

El Pasoans ascribed various reasons to the sudden closing of the restaurant. Successful restaurateur Jack Maxon (see chapter 9) believed that the location made the restaurant difficult to reach. In 1998, a reporter for *El Paso Inc.* wrote, "The building is hidden behind the imposing Yandell Drive overpass onto Paisano. Motorists coming from downtown El Paso must make an awkward U-turn off Paisano onto a frontage road to get to it."[39] Others, like Metz, countered this thinking, explaining that in its heyday, La Hacienda drew people from all over town, especially downtown employees and UTEP students.[40] Instead, he believed that with the change of ownership, the quality of the food declined.

Perhaps the best explanation was economic. Repairing and maintaining the building required a tremendous amount of capital. Around the time of La Hacienda Café's closing, El Paso did not fare well financially, and the neighborhood in which the restaurant was located received negative

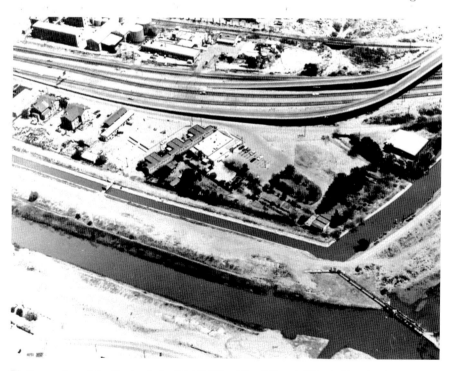

Bird's-eye view of La Hacienda (*center*), Old Fort Bliss (*left*) and Oñate's Crossing (*center right*) from the Mexican side of the Rio Grande, circa mid-twentieth century. *El Paso County Historical Society.*

press for being dangerous.[41] Though others have considered reopening the restaurant, politics and economics have once again intervened to keep the building and the land on which it sits marginal and all but detached from the rest of El Paso. Millions of dollars in highway funds have been spent to construct massive overpasses and expressways extending from Paisano Drive. U.S. Customs and Border Patrol agents relentlessly patrol the historic half-mile stretch encompassing La Hacienda Café, Oñate's Crossing and Old Fort Bliss. Neglect of the area and apathy toward historic preservation stemming from local government prevent much from being done to revitalize it. Granted, several officials from El Paso County and other civic leaders have funded and tirelessly promoted studies highlighting the significance of this historic stretch of land and its extant structures. On balance, however, this vitally significant area—one that connects El Pasoans to their Indigenous, Spanish, American and Mexican past—is best described today as Fred Evans, one of my colleagues, puts it: *El Paso Del Concreto* (the Pass of Concrete).

And yet this development further envelopes La Hacienda Café in the broader history of the borderland. Histories of current trends in economic and infrastructure development, immigration and fraught border relations at a time when xenophobia runs high will all be written in the future. La Hacienda, once again, sits at the center of Paso Del Norte's history, even if its physical location is not easy to locate.

2

The Central Café

JOE LEWELS

O ver a century ago, El Paso's most famous restaurants were not actually in El Paso, or even in the United States. They were in El Paso's sister city of Juárez, Chihuahua, Mexico—an easy stroll over the international bridge from downtown El Paso. One of Juárez's most famous establishments was the Central Café, which wasn't only a restaurant noted for an eclectic variety of dishes, but also a showplace of great renown, with a ballroom for dancing, its own ten-piece orchestra, slot machines and a long, beautifully crafted bar.

Central Café's humble beginnings date back to 1907, when it opened as a small family restaurant three years before the start of the bloody Mexican Revolution (1910–20).[42] The business somehow survived three major battles for control of Juárez fought between the revolutionary army of the infamous Pancho Villa and the forces of the federal government.[43] El Pasoans on the opposite bank of the Rio Grande watched in horror and amazement as gun battles raged and Mexican citizens fled across the border.[44] But then, in 1920, two events propelled the Central Café and Juárez into their most profitable (some say glorious) decade: the end of the revolution and the beginning of Prohibition in the United States.

During these glory years, which spanned the 1920s and 1930s, the Central played an important role in El Paso. The mastermind behind the conception of the Central was a showman and promoter who took full advantage of the social changes in the United States and Mexico. He turned his café into

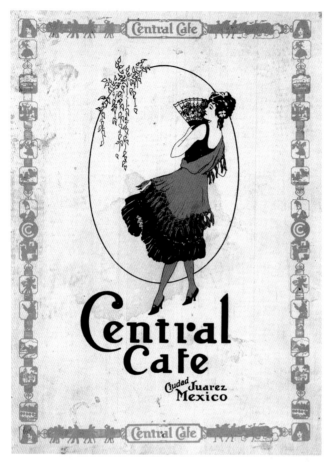

Left: Central Café menu cover, circa 1920s. *Mike Daueble*.

Below: Post Office in Juárez after the Battle of Juárez, May 1911. *El Paso County Historical Society*.

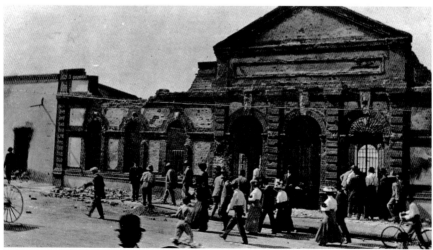

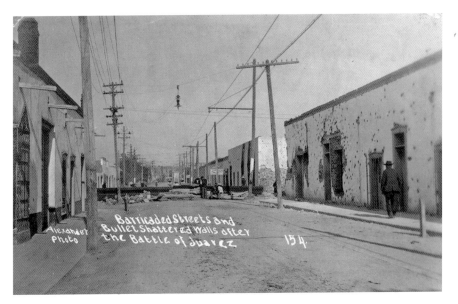

Damaged buildings following the Battle of Juárez, May 1911. *El Paso County Historical Society.*

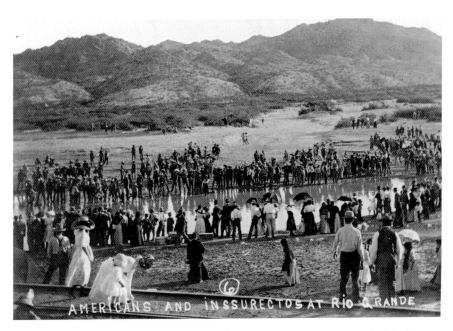

El Pasoans would camp at the Rio Grande to watch battles in Juárez during the Mexican Revolution. *El Paso County Historical Society.*

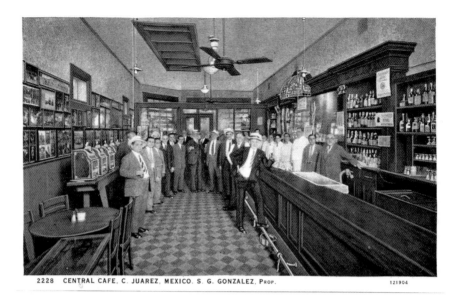

2228 CENTRAL CAFE, C. JUAREZ, MEXICO. S. G. GONZALEZ, PROP. 121904

Central Café bar, circa 1920s. *Mexicoenfotos.com.*

a cabaret and dance palace—an attraction not only for the social elite of El Paso but also for adventurous Americans. He brought in some of the best musicians to play in his orchestra; he sponsored cockfights to entertain his amazed patrons; he owned a baseball team (for which he built the first grassed-in baseball field in Juárez); and he once brought in ex-heavyweight champion of the world Jack Dempsey for an exhibition bout in an arena that he built for the occasion. This man, Severo G. Gonzalez (known as "S.G."), was the borderland's answer to P.T. Barnum—a man with a wild imagination and great ambition. His success topped even his wildest expectations as celebrities and politicians flocked to the Central, making Ciudad Juárez a destination vacation spot.[45]

INTERNATIONAL RECOGNITION

To be sure, the cuisine of the Central Café was not the only attraction, or even the main one, for tourists who flocked to the borderland. One historian, Robin Espy Robinson, goes so far as to assert, "The city of Juárez became 'The Monte Carlo of the border.'" Casino-style gambling, cockfights, dice games, slot machines and brothels all contributed to the

economic bonanza that the city enjoyed in those early years when El Paso and Juárez seemed not to fully belong to either the United States or Mexico but to a little kingdom of their own with an inseparable economy. The two cities had a much more intimate relationship in those years. One could easily drive or walk from one downtown area to the other in just a few minutes with no identification. Americans returning from Juárez needed only to utter the words "American" or "U.S." to customs officers to enter El Paso, no matter how drunk they might have been. Easy transit made tourism a great attraction for Americans dealing with the restrictions of Prohibition.[46]

The windfall in tourism was a bonanza for Juárez, and El Paso officials were quick to cash in as well. The El Paso Chamber of Commerce launched a national campaign to promote its newfound opportunity, describing El Paso as a place "where the sun spends the winter…across from charming Juárez." By 1922, Robinson reports, "there were 20,000 rail passengers (annually) with a 10-day stop-over passing through El Paso."[47] The notoriety of the Central and of Juárez as a place where Americans could go to party was the topic of a full-page article in the March 8, 1931 issue of the *New York Herald Tribune*:

> *Juárez was a town before the Pilgrims left England, but the collection of adobe structures across the Rio Grande from El Paso, Texas had to*

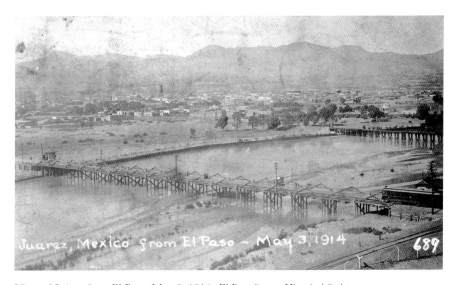

View of Juárez from El Paso, May 3, 1914. *El Paso County Historical Society*.

ENTREMESES

COCTEL DE CANGREJO	$	18.75
COCTEL DE CAMARON	"	18.75
CEVICHE A LA MARINERA	"	18.75
COCTEL DE OSTIONES FRESCOS	"	15.60
CORAZONES DE ALCACHOFAS A LA VINAGRETA	"	18.75
COCTEL DE FRUTAS ESTILO HAWAIANO en Brandy de Cereza	"	12.50
COCTEL DE AGUACATE CON CREMA	"	12.50

SOPAS Y CALDOS

SOPA DE CEBOLLA GRATINADA	$	7.50
SOPA DE CREMA VICHYSOISSE en Frío	"	7.50
CREMA DE CHAMPIÑONES	"	7.50
CALDO TLALPEÑO	"	7.50
POTAGE DE ALMEJAS A LA LOUIE	"	10.00

ENSALADAS ESPECIALES

ORIGINAL CESAR (Para Dos)

Frescas y Seleccionadas Hojas de Lechuga Romana, Crutones Dorados Anchoas y Queso Parmesano Aderesado con Salsa a Base de Limones y Ajo al Gusto y Preparado en su Mesa $ 31.25

ENSALADA ESPECIAL DEL MAITRE'D (Para Dos)

Frescas y Seleccionadas Hojas de Lechuga Romana, Trocitos de Aguacate, Rábano y Tomate Aderezado con Queso Roquefort, Aceite, Vino Tinto y Ajo al Gusto y Preparado en su Mesa " 31.25

OTRAS ENSALADAS

ENSALADA CHIEF con Rebanadas de Pollo, Jamón y Queso, Tomate y Lechuga Fresca Aderezo a Escoger " 18.75
ENSALADA FIESTA con Selectos Camarones y Rebanadas de Jamón Aderezo a Escoger " 18.75
AGUACATE RELLENO de Ensalada de Pollo o Camarón " 18.75

CANAPES SURTIDOS

De Caviar, Hígado de Ganso, Ostiones Ahumados, Camarones y Pollo Docena " 35.25

BOTANAS

CHILE CON QUESO con Tostadas " 10.00
GUACAMOLE CON TOSTADAS " 10.00
TOSTADAS JALAPEÑAS (Nachos) " 10.00
CARNES FRIAS SURTIDAS " 18.75

SANDWICH DE LUJO

PEQUEÑO STEAK DE LOMO Servido con Ensalada de Papa en Sandwich Abierto " 25.00
CLUB HOUSE SANDWICH CENTRAL ESPECIAL " 18.75
JAMON O CORNED BEEF SANDWICH " 15.60

DISFRUTE SU VINO FAVORITO
DE NUESTRA EXCELENTE SELECCION

wait 300 years for Prohibition in the United States before becoming a city. Thirsty Americans crossing the border have stimulated Juárez into a greater growth in the last decade than it had enjoyed throughout the entire course of its previous three centuries. Block after block of new saloons and cabarets today proclaim the border metropolis as a city literally built by thirst…. Juarez has two breweries, three big distilleries and between 200 and 300 saloons of the "better class"…practically all of the city's revenue comes from levies…on these establishments.

CARNES

STEAK CORTE NUEVA YORK USDA El Corte de Reyes	$ 56.25
T-BONE STEAK USDA de Gran Corte Perfecto	" 56.25
FILETE MIGNON CORTE SUPREMO el más Tierno de los Steaks ..	" 43.75
FILETE MIGNON PETITE Jugoso y Selecto	" 34.35
TOP SIRLOIN Calidad Suprema	" 37.50
STEAK NUEVA YORK	" 37.50
T-BONE STEAK ...	" 37.50
TIERRA Y MAR, LANGOSTA Y FILETE PETITE, ESPECIALIDAD CENTRAL CAFE	" 74.40
ASADO DE RES AL HORNO con Gravy Especial y Puré de Papas ...	" 25.00
JAMON VIRGINIA CON RUEDAS DE PIÑA con Nuestra Salsa Especial ..	" 25.00
SPAGHETTI CON ALBONDIGAS	" 25.00

MARISCOS

COLA DE LANGOSTA con Mantequilla y Limón Malteado	" 68.75
BOQUILLA BLACK BASS con Nuestra Especial Salsa Tártara ..	" 37.50
BOQUILLA FILETE DE PESCADO AZUL	" 34.40
FILETE DE PESCADO BLANCO CAPRICE con Ligera Salsa de Mostaza Adornado con Plátano Frito	" 31.25
CAMARONES FRITOS A LA FRANCESA con Cebollas Fritas ..	" 31.25
ANCAS DE RANA FRITAS EN MANTEQUILLA con Salsa Tártara ..	" 31.25
NUESTRA ESPECIAL COMBINACION DE MARISCOS, Ancas de Rana, Filete de Pescado, Camarón y Escolapitas	" 31.25

GALLINA

PECHUGA DE POLLA A LA KIEV Servida en Pilaf de Arroz con Salsa Holandesa	" 31.25
MEDIO POLLO FRITO A LA PARRILLA Sazonado con un Gusto Exquisito Servido con Tomate Asado	" 25.00
POLLO A LA CANASTA con Papas Fritas	" 25.00

ESPECIALIDADES MEXICANAS

CARNE ASADA A LA TAMPIQUEÑA Servida con Arroz, Enchilada Verde, Frijoles Refritos, Guacamole y Rojas de Chile ..	" 37.50
CALDILLO DE FILETE	" 31.25
COMBINACION DE PLATILLO MEXICANO Chile Relleno, Taco, Tamal, Enchilada, Chicharrón, Arroz y Frijoles ...	" 25.00
POLLO EN MOLE POBLANO en Riquísimo Mole Preparado Verde o Rojo Servido con Arroz y Frijoles	" 25.00
ENCHILADAS, ROJAS O VERDES O CON CREMA	" 18.75
TACOS DE CARNE O POLLO	" 15.60
CHILES RELLENOS DE QUESO O DE CARNE	" 18.75

SUGESTIONES DEL MAITRED

CHATEAUBRIAND MAITRED HOTEL (Para Dos) un Gran Corte de Filete Parrillado a la Perfección Sauteado con Vino Tinto y Champiñones, Flameado en Cognac y Servido a su Mesa ..	"125.00
STEAK AUPOIVRE Corte de Lomo de Res Prensado en Pimienta Fresca Sauteado en Vino Tinto y Cognac conn Salsa Bernesa (Para Dos)	"100.00
TOURNEDOS A LA LOUIE Medallones de Filete Sauteados en Ajo, Aceite y Vino Tinto Coñac Servido con Salsa de Champiñones (Para Dos)	*I*00.00
LOUISIANA PRAWNS Selectos Camarones Gigantes Estilo Mariposa Sauteados con Vino Blanco Ajo y Aceite, Mantequilla, Paprika, Flameado y Servido Sobre Arroz Gitano (Para Dos) ...	" 87.50
ROQUEFORT STEAK, un Corte de Lomo de Res Sauteado con Aceite, Ajo al Gusto, Vino Blanco Malteado con Queso Roquefort y Flameado con Coñac (Para Dos)	"112.50
SHISH-KA-BAB, Trozos de Filete de Carnero a la Marinera, con Cebolla, Tomate y Pimiento Servido en Espada Flameante ...	" 49.40
BROCHETA DE FILETE EN ESPADA FLAMEANTE Filete de Res, Cebolla y Pimiento, Servido en Arroz Gitano	" 49.40

POSTRES Y ESPECIALES

PREPARADOS Y FLAMEADOS A SU MESA (Para Dos)

CHERRIES JUBILEES	" 31.25
CREPES ZUSSETES ..	" 31.25
PLATANO FLAMEADO	" 31.25
DURAZNO FLAMEADO	" 31.25
PIÑA A LA PERNOD	" 31.25
Y NUESTRO ESPECIAL CAFE IRLANDES con Legítimo Whisky Irlandés y Crema Chantilly Flameado Elegantemente a su Mesa ...	" 31.25

POSTRES

PASTEL DE QUESO ..	" 6.25
PASTEL DE QUESO CON FRESAS	" 8.75
PASTEL DE PASAS CON SALSA DE BRANDY	" 5.60
HELADO ESPECIAL con Chocolate, Coco y Cherrie	" 7.50
DURAZNO A LA MELBA con Nuestra Mermelada Especial	" 7.50
HELADO ..	" 3.75

SU SELECCION CON SOPA, ENSALADA ADEREZO A ESCOGER
PAPA AL HORNO O FRANCESA, PAN, CAFE O TE.

Above and opposite: Central Café menu, circa 1920s. *Mike Daueble.*

The article goes on to list the principal establishments: "the Mint, the Central, Big Kids, the Lobby, the Tivoli" and numerous lesser-known businesses.[48]

The Central Café became so prosperous that Severo Gonzalez opened a second restaurant and cabaret in May 1924—Central Café Number 2—adjacent to the international bridge on Juarez Avenue. Both cafés pampered their guests in air-conditioned comfort. Their menus featured not only Mexican plates of tacos, tamales, enchiladas and refried beans,

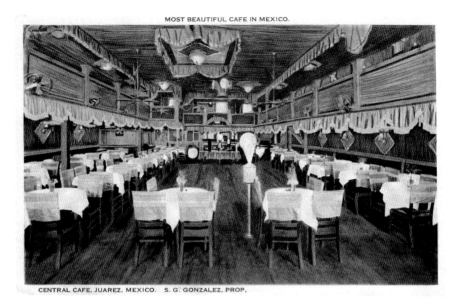

Central Café ballroom, circa 1920s. *Mexicoenfotos.com.*

but also chateaubriand for two, assorted steaks, mallard duck, teal duck, quail and fresh black bass from Boquilla Lake in Chihuahua. Much of the produce was grown on Gonzalez's own farm in southeast El Paso. In short, both incarnations of the Central Café "set the standard for sophisticated establishments catering to a first-class clientele."[49]

S.G. GONZALEZ

Severo "S.G." Gonzalez, a native-born El Pasoan, was a businessman for whom the international border was an opportunity for profit. Americans wanted their liquor, and Gonzalez and Ciudad Juárez were most happy to provide it. Shortly after his death, the *El Paso Times* stated that he:

> *won fame as the operator of the old Central Café in Juárez in the early days of the Prohibition-era, where he personally entertained royalty in the world of entertainment who visited the border....Don Severo, for more than half a century, was a figure of note in the liquor, restaurant and sports circles in El Paso and Juárez. He also took part in civic affairs in the two cities. The stocky, white-haired, cigar-smoking Don Severo opened his*

*Central Café No. 1 at the corner of 16th of September and Lerdo Avenues
and made it one of the showplaces of Mexico during the Prohibition era.
Movie stars such as Buster Keaton, Fatty Arbuckle, Norma Talmadge,
top stars of the silent screen, made frequent trips to El Paso to visit S.G.
at the Central Café. Keaton and Arbuckle were his most frequent visitors.
S.G. once recalled that the two movie stars, at the height of their careers,
entertained his customers with impromptu floor shows, for the entertainment
of his clientele.[50]*

El Paso newspapers heaped praise on the Central Café for decades. The
June 27, 1922 issue of the *El Paso Herald-Post* carried a story exclaiming the
grandeur of the new cabaret: "Severo G. Gonzalez, proprietor of the Central
Café in Juárez has redecorated his amusement resort in gold and it now rivals
anything on the Pacific Coast....Los Angeles hasn't a cabaret as elaborately
decorated unless it is the famed Cocoanut Grove in the Hotel Ambassador."[51]

An article in the *El Paso Times* on May 10, 1924, referred to Gonzalez as
"a valued citizen" and "philanthropist" who purchased supplies for the jail
and hospital and contributed to relief funds and civic organizations.[52] But
even as good publicity mounted and as successful as the Central became,
Gonzalez still bore resentment toward the way it was portrayed in the media.
He wanted the public to know that it was not only Prohibition and liquor
that made his establishment popular. In his mind, at least, the Central's
success was due to it being a family restaurant—a safe and decent place
where people could feel comfortable, even with their kids.

To promote this idyllic image of his establishment, Gonzalez was willing to
spend money on full-page ads in El Paso newspapers. On June 16, 1922, the
El Paso Times ran an advertisement for the Central, signed by the proprietor
himself, proclaiming:

*The Central Café is an institution of the Middle Border. It did not spring
up on a wave of reform but has long been a place in Juárez where Americans
could go with their families and friends and enjoy an evening of good music,
dancing and wholesome fellowship. With the completion of improvements in
the Central Café, including the only cooling system in Juárez, soft draperies
and subdued lights, I am rededicating the Central Café to my friends on
both sides of the Rio Grande whose encouragement and patronage has made
the new Central Café possible....We have arranged a special program of
entertainment...a concert by the Pacific Coast Paramount Players and
dancing music deluxe by the Central Orchestra.[53]*

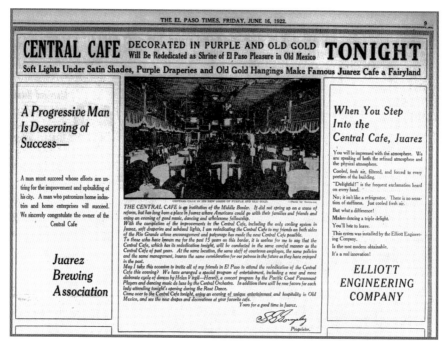

Central Café advertisement signed by S.G. Gonzalez and published in the *El Paso Times*, June 16, 1922. Public domain.

ENTERTAINMENT AT THE CENTRAL CAFÉ

The *El Paso Evening Post* reported on February 28, 1929, that the Central was "probably the most widely known café on the entire Mexican border.... Thousands of tourists visit this famous resort every year." The article further reported that the establishment was praised by celebrities such as H.L. Mencken (editor of *American Mercury Magazine*), Joseph Leopold (president of the United States Chamber of Commerce), international banker Otto H. Kahn and Karl Herriman (editor of *Redbook Magazine*).[54]

There is little doubt that a great part of the public's attraction to the Central was the entertainment provided by occasional guest artists and its own tuxedo-clad orchestra, which played tunes made popular by the big bands of New York led by Benny Goodman and Glenn Miller. Much of this had to do with a chance encounter that Gonzalez and his wife had in 1926 with bandleader, recording artist and trumpet player Frankie Quartell while they were on their way to the Kentucky Derby. Quartell played trumpet

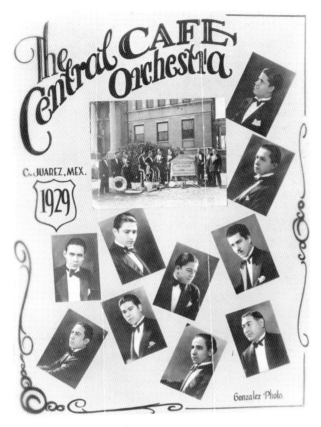

Left: Central Café orchestra, circa 1929. *University of Texas at El Paso Library, Special Collections Department.*

Below: Orchestra on bandstand, circa 1920. *Mexicoenfotos.com.*

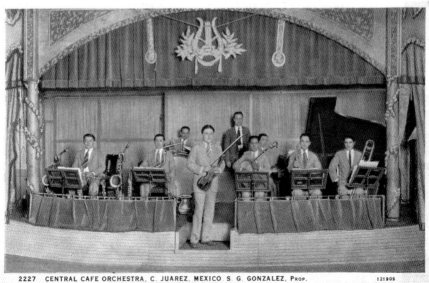

43

with the orchestra of the Edgewater Beach Hotel in Chicago at the time. The hotel sponsored a chartered train each year from Chicago to Louisville for the derby. It would leave Chicago in the morning and stop in French Lick, Indiana. The purpose of the stop was to allow the passengers to enjoy the seven gambling establishments that thrived there. This was a place where "the rich and famous came to gamble." The next day, the orchestra played a concert in the lobby of the French Lick Springs Hotel, and after the concert, Quartell met Mr. and Mrs. Gonzalez. Three years later, Quartell moved to El Paso, in part to seek employment, but also because his wife had contracted tuberculosis and her doctor recommended the move to a drier climate. When he contacted S.G., they agreed on a salary of $250 a week, and Quartell became the new leader of the Central orchestra's 10-piece band, which consisted of eight Mexican and two American musicians. Working hours were from 6:00 p.m. to 11:45 p.m. The closing time was set to allow American tourists to get across the bridge, which closed at midnight. (If they missed the curfew, they would have to stay in Juárez overnight.)[55]

Quartell spoke highly of Gonzalez and those who frequented the Central. Of the businessmen from El Paso who visited the Central Café regularly, he mentioned Bill Tooley, owner of the Knox Hotel; Louis Zork of the Zork Hardware Company; Johnny Frierson, editor of the *El Paso Herald-Post*; Leo Munson of Munson, Dunnigan and Ryan Company; Bill Hoover of the Cotton Exchange; W.J. Hooten of the *El Paso Times*; and Dorrance Roderick, publisher of the *El Paso Herald-Post* and *El Paso Times*. Regarding other notable customers, Quartell stated: "I met Conrad Hilton Sr. at the Central Café. He was in El Paso to start the building of the Hilton Hotel [presently known as the Plaza Hotel]….Louella Parsons, the famous Hollywood columnist (and her husband) were spending their honeymoon in El Paso and were in the Central Café [where they] dined and danced every night of the two weeks they were here." Quartell added, "Mr. Gonzalez was a great human being and promoter….He helped and financed a young Mexican boy to start a radio broadcast from…the Central Café. He also helped a crippled lady in Juárez—bought her leg braces so she could walk."[56]

THE PARTY ENDS

It was inevitable. The party had to end sooner or later. The American public had enough of Prohibition, and they rebelled against it until it was finally

repealed in 1933. Soon, festivities resumed on the U.S. side of the border. Texas was stubborn, however, refusing to repeal its own laws against the consumption or sale of alcohol until 1935, so El Pasoans remained reliable patrons at Juárez establishments. Nevertheless, the Great Depression and the end of Prohibition in the United States inflicted a one-two punch to nightlife across the border. Some of the establishments simply moved to the United States, while others subsisted in the depressed environment. Overall, many bars and nightclubs closed as tourism faded away.

Gonzalez, ever the sharp entrepreneur, adapted to the changes. He kept Central Café No. 2 near the bridge open, where it remained a popular spot until it finally closed after his death in 1971. He also opened Central Café No. 3 in El Paso's Lower Valley. The September 24, 1935 issue of the *El Paso Herald-Post* ran a full-page ad announcing its grand opening:

> *You are invited…to attend the opening of the new Central Café in its brand new home on the lower valley highway.…S.G. Gonzalez, who made the old Central Café internationally famous by his expert direction, will be in personal charge. Recently completed by Mr. Gonzalez on his beautiful lower valley estate, one of the show places of the valley, the new Central Café promises to take the place of the famous Central Café in Juárez for the popularity with the El Paso people…*[its] *own dancing and drinking place right at its front door.*[57]

And so the legacy of the famous cabaret was carried forward in El Paso, but it was never to reach the status and grandeur of its previous life in Juárez during the Roaring Twenties.

After S.G. Gonzalez died, his restaurants closed, and his great legacy faded. But an interesting thing happened. A young restaurateur in El Paso, Mike Daueble, who owned a steakhouse downtown called Miguel's Steaks and Spirits, purchased the long, beautiful bar from the Central. According to Daueble, he installed the front part of the bar in his second Miguel's in west El Paso on Shadow Mountain Drive. He put the back of the bar in storage until 1988, when he opened a third restaurant behind the Plaza Hotel at 109 North Oregon Street, which he named Miguel's Café Central.[58] The Oregon Street location remained open until 1998, when Daueble sold it. It was later reopened by different owners, and "Miguel" was dropped from the establishment's name. Today, it is known as Café Central and remains one of El Paso's most popular and upscale restaurants. Unfortunately, the front of the bar that once graced the

Café Central in downtown El Paso, June 2019. *Photo by Sarah Duenas*.

The back of the bar was previously located at Central Café in Juárez. It is currently located at the Café Central in El Paso. *Alejandro Orozco, owner*.

Café Central dining room in El Paso. *Alejandro Orozco, owner.*

Central Café in Juárez was sold at auction, and its location is presently unknown. Nevertheless, the back of the bar is still in place at Café Central as a subtle reminder of its predecessor's grander days.

It seems that the legacy of Severo Gonzalez's Central Café will never be completely erased from *paseños'* memories. And that is a good thing, because without our history we are a people with amnesia—ignorant of our sometimes glorious and, at other times, less than glorious, past.

3

Home of the Special Fizz

Prohibition, Harry Mitchell and the Mint Café, 1926–35

BRAD CARTWRIGHT

An advertisement for Harry Mitchell's popular bar and restaurant, which opened in December 1926 in Juárez, Chihuahua, Mexico, unabashedly claimed, "What Delmonico's was to New York, the Poodle Dog to San Francisco and Fabacher's to New Orleans, the Mint Café is to El Paso and Juárez."[59] Known for its "Special Fizz," as well as its fine foods and entertainment, Mitchell's bar and restaurant witnessed a meteoric rise and fall in the 1920s and 1930s. From its long list of celebrity visitors to allegations of drug trafficking by its owner, the Mint Café's successes and failures can be directly attributed to Prohibition in the United States and the complex, yet celebrated, Harry Mitchell.

Born in England in 1888 and raised in Canada from the age of two, Harry Mitchell left home as a teenager to make his way in the United States. He eventually arrived in San Francisco just after the massive 1906 earthquake, which destroyed more than 80 percent of the city's infrastructure. At that time, Mitchell began his career in bartending at the Palace Hotel.[60] In 1912, like many others in the early twentieth century seeking to improve their health, he made his way to El Paso for the dry and sunny climate. It was there that Mitchell married his wife, Lela, and built on his bartending career at the Hotel Paso del Norte. Mitchell eventually enlisted in the U.S. Army, was stationed at Fort Bliss and served for five months beginning in July 1918.[61]

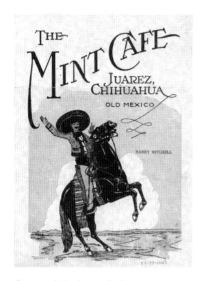

Cover of the Mint Café's menu and drink list. *El Paso County Historical Society*.

On his return to El Paso, the Eighteenth Amendment to the U.S. Constitution was nearing ratification; the prohibition of alcohol loomed across the nation. As one might expect from someone who had made a career in the bar business, Mitchell looked to Ciudad Juárez—just a short walk across the Rio Grande from El Paso, Texas—for opportunities made illegal in the United States. Thus, Prohibition ushered in a new era along the U.S.-Mexico border, during which Mexican and American businessmen used Mexico's "wet" status to legally slake the thirsts of those unhappy with America's newly legislated morality. In fact, Ciudad Juárez would experience significant prosperity during the era of Prohibition as restaurateurs, nightclub owners and bartenders sought newfound entrepreneurial prospects on the Mexican side of the border.

On the other hand, partly as a result of political instability in Juárez that lingered after the Mexican Revolution, a series of new challenges arose as Americans flocked to these new businesses. To get a sense of the challenges posed by Mexican authorities, one can start by looking at the number of tourists who crossed into Mexico before and after Prohibition. From July 1918 to July 1919, 14,130 tourists traveled from the United States across the border into Mexico; yet, from July 1919 to July 1920, that number skyrocketed to 418,735—83,456 of whom crossed the Rio Grande from El Paso into Ciudad Juárez.[62] Thus, while Ciudad Juárez offered fine dining and cocktails within its rapidly growing number of cafés and bars, the proprietors of these establishments faced a series of new obstacles from Mexican authorities and labor unions. For example, both local and state officials often required business owners to pay a *mordida*, or hush money payment, to remain in business.[63] These payments could dramatically reduce a business owner's profits. Moreover, most owners catering to the rapidly developing Juárez tourist trade, in order to receive assistance and protection from the local police force, had to hire policemen to maintain order in their bars and restaurants. Lastly, more and more waiters and bartenders became unionized during the 1920s under the Mexican national labor union—

Paso Del Norte Hotel, completed in 1912. *El Paso County Historical Society.*

the Confederación Regional Obrera Mexicana (CROM)—which made it increasingly difficult to fire or lay off Mexican service staff.

Despite these and other complications, Harry Mitchell took advantage of the moment to open the Mint Café on Christmas Eve 1926.[64] An advertising card noted the following:

> *Finished in a green color scheme to fit its name, the Mint is a cool, inviting café where men may take their wives and families and where an air of quiet refinement makes the wonderful food and service doubly enjoyable. Wild*

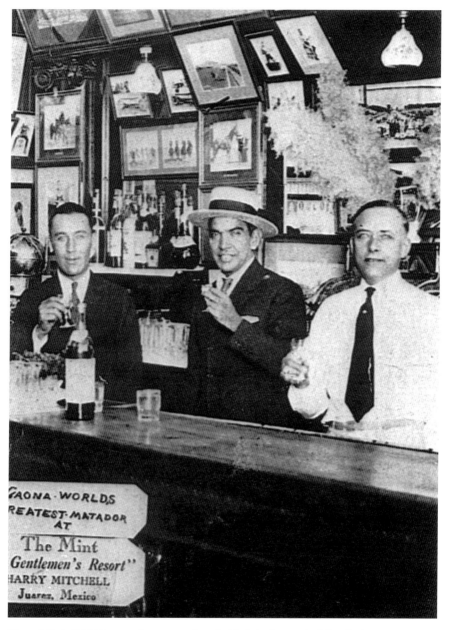

Harry Mitchell (*right*) toasts the camera from behind the bar at the Mint Café. *El Paso County Historical Society.*

game, Mexican dishes, steaks, fish and chops are served at the Mint Café
to your order and the chef will be glad to prepare any special dish you may
desire and to arrange in advance for dinner parties.[65]

In a relatively short amount of time, the Mint Café became one of the top restaurants and nightclubs on Juárez's *Avenida 16 De Septiembre* (16th of September Avenue). Central to its success was its robust food and drink menu, Mitchell's persistent and effective advertising, and the Mint's popularity among residents of the borderland, as well as celebrities, politicians and sports figures known the world over.

The Mint Café's menu opened with the motto, "Every day is good food day at The Mint."[66] A. Carlsen, who served as head chef of the Mint from 1927 to 1933, had "earned an enviable reputation" for "catering to the discriminating food connoisseurs of Europe, the United States, and Mexico."[67] Carlsen's food offerings were extensive, featuring a range of local, national and international flavors. One could sample a variety of appetizers, such as caviar canape or French hors d'oeuvres, as well as a wide range of soups—including mock turtle, oxtail and Coney Island clam chowder. The menu offered a range of oysters and shellfish, including Crab Ravigote and Lobster Louis, and items from the "Finny Tribe," such as jumbo frogs and local black bass and trout. And while one could order a variety of fowl and game, including venison, rabbit or duck, the Mint Café prided itself on its steaks and chops. In particular, Carlsen featured Kansas City strip steaks, filet mignon, pork and veal chops and a variety of schnitzels. Of course, there were Mexican dishes as well. These included enchiladas, "chili" rellenos, chicken mole, huevos rancheros, frijoles refritos (refried beans) and quesadillas. If all of this were not enough, one could order from a large variety of cold meats, sandwiches and salads. Moreover, for the extremely discriminating customer, the menu stated, "Our Chef will gladly prepare for you your favorite dish, whether on the menu or not."[68] Overall, with noonday luncheons costing fifty cents and top sirloin going for seventy cents, the prices at the Mint were similar to restaurants in New York City.[69]

Yet the Mint Café's biggest draw was perhaps bartender Harry Mitchell and his wide-ranging drink menu in an era when the manufacturing and transportation of intoxicating liquors in the United States was illegal. For wine aficionados, the menu began with champagnes; sauternes (sweet wines); and Spanish, Italian, Mexican and Rhine wines. The Mint Café served a variety of beers, including a German lager, an Irish stout and an English ale. They also offered Mexican bottled and draft beers, such

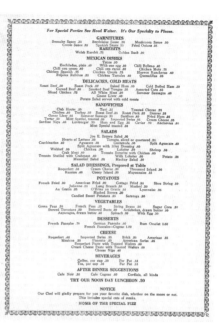

Above: The Mint's food menu featured an array of local, regional and international dishes. *El Paso County Historical Society*.

Left: The Mint's drink selection was extensive and certainly an indication of Harry Mitchell's years in the bartending business. *El Paso County Historical Society*.

as Carta Blanca, Orizaba, Austriaca and Juárez. Mitchell served different gins, rums, cordials, vermouths and a range of Irish, Scotch, American and Canadian whiskeys. The menu stated that the Mint's "bar service includes all and every kind of mixed drink" and that "if you don't see what you want on this list, ask for it, and we will see that you get it."[70] Among the mixed drinks listed, some of the interesting offerings included the Calamity Jane, the Sherry Flip, the Millionaire Sour, the Blue Moon, the Broadway Jones, the Absinthe Frappe, the Maple Leaf and the Zazarack. But there was one drink that the Mint Café was known for far and wide: Harry Mitchell's Special Fizz.[71] Other "fizzes" included the Morning Glory, the Mint Toddy and the Mint Mash.

If the food and drink menus at the Mint were not enough to lure customers into Juárez, Harry Mitchell's knack for advertising certainly encouraged others to visit his café. First and foremost, the Mint's ads were never short of hyperbole. One read, "The Mint Café is known everywhere as the rendezvous of the notable." One stated, "your search for the finest café ends here."[72] Another boldly claimed, "Once You Eat at the Mint You Will Always Eat at the Mint."[73] Mitchell also established an image for the Mint that was based on its clientele, atmosphere, foods and service. Though the majority of the café's advertisements referred to the Mint as the "Home of the Special Fizz" and as "A Gentleman's Resort," Mitchell made it clear that women were welcome at the Mint.[74] One ad declared, "Ladies, Too, Enjoy Dining at the Mint. The gentlemen whose guests are ladies dine at the Mint with that pleasing assurance of those special courtesies that ladies appreciate."[75] And another claimed, "The Mint is a place where ladies may come without fear of criticism and where they can spend a pleasant hour at luncheon or at dinner in the evening."[76] Lastly, Mitchell often used advertising to reflect on his restaurant's success:

> *Today the Mint is an institution in Juárez. Its fame has extended to every part of Mexico and the United States and to lands beyond the seas. The tourist and the wayfarer cherish fond memories of the faultless food and perfect service obtained at the Mint and they have spread its fame to the uttermost ends of the earth. Statesmen and soldiers, artists and writers, financiers and captains of industry, men and women whose names are household words throughout civilization, have been guests at the Mint. They have lauded its hospitality and praised the perfection and completeness of its menus and service.[77]*

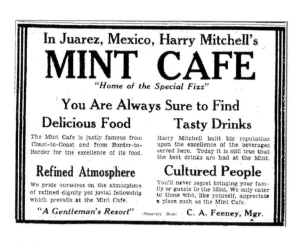

In Juarez, Mexico, Harry Mitchell's

MINT CAFE

"Home of the Special Fizz"

You Are Always Sure to Find

Delicious Food

Tasty Drinks

The Mint Cafe is justly famous from Coast-to-Coast and from Border-to-Border for the excellence of its food.

Harry Mitchell built his reputation upon the excellence of the beverages served here. Today it is still true that the best drinks are had at the Mint.

Refined Atmosphere

Cultured People

We pride ourselves on the atmosphere of refined dignity yet jovial fellowship which prevails at the Mint Cafe.

You'll never regret bringing your family or guests to the Mint. We only cater to those who, like yourself, appreciate a place such as the Mint Cafe.

"A Gentleman's Resort" (Recovery Item) **C. A. Feeney, Mgr.**

Many of Harry Mitchell's advertisements focused on the Mint's "refined atmosphere" and "cultured people." *El Paso Herald-Post,* January 6, 1934. El Paso Herald-Post.

Again, one cannot help but notice the use of hyperbole in Mitchell's description of his restaurant, its food and service, its worldly recognition and its famous clientele.

It is in fact true that many well-known individuals and celebrities visited the Mint Café. Among others, these included the famous cartoonist Sydney Smith. Creator of the popular cartoon "The Gumps," Smith was the first comic-strip artist to sign a $1 million contract, and his work served as the inspiration for Amos and Andy. Will Durant was another famous patron of the Mint. An American philosopher, historian and writer, Durant is perhaps best known for writing *The Story of Philosophy* (1926) and the first six volumes of *The Story of Civilization* (1935–57). Dudley Field Malone, who joined Clarence Darrow as co-counsel in the famous Scopes Monkey trial, similarly graced the "Home of the Special Fizz." Another patron who received a lot of attention in local newspapers was New York mayor Jimmie Walker, who visited El Paso and Juárez in June 1928. Traveling through El Paso on his way to California, Walker had just left the Democratic National Convention in Houston, where New York governor Al Smith had been nominated as the party's presidential candidate. While dining, drinking and dancing at the Mint, Walker claimed, "Notwithstanding my great devotion to my country I found it almost impossible to remain out of Mexico….Ours is the land of liberty and freedom, but we have to come to Mexico to get it."[78]

Many famous athletes frequented the Mint Café as well. Among others was Tommy Armour, a Scottish American professional golfer who won the U.S. Open in 1927, the PGA Championship in 1930 and the Open Championship in 1931. Joe Kirkwood, another professional golfer to visit the Mint, was the first Australian to win a tournament on what would become the PGA Tour. Ted Coy was a first team All-American football

player from Yale who led his team to a 10-0 record in his senior year, in which they outscored their opponents, 209–0. He dined at the Mint Café and was praised by Mitchell as "one of the greatest football players that ever graced the field."[79] Lastly, the Mint Café hosted Jack Dempsey, professional boxer and heavyweight world champion from 1919 to 1926, who also visited S.G. Gonzalez's Central Café in Juárez around the same time. An expert booster, Harry Mitchell took advantage of celebrity fame to promote his bar and restaurant.

Interestingly, the Mint Café also attracted many famous aviators during a formative era in aviation, when military and civilian flight technology rapidly advanced and flight record-setting captured the nation's attention. An advertisement references Colonel William "Billy" Mitchell, commander of American air combat troops in France during World War I and a tireless advocate for increased investment in air power. It also mentions Admiral Richard Byrd, an American naval officer, aviator and polar explorer. But perhaps the most well-known pilots who dined at the Mint were Lieutenant Emilio Carranza and Amelia Earhart. Carranza, at the age of twenty-one, made aviation history when he flew nonstop from Mexico City to Juárez in ten hours and thirty-six minutes on September 2, 1927. It was Carranza's goal to stay in the El Paso area until September 24 in order to meet the world's most famous aviator, Charles Lindbergh, who was scheduled to visit Fort Bliss on a seventy-five-city tour around the United States. At the Mint Café, Carranza offered Lindbergh the following ice-water toast: "Drink with water in respect to the abstinence of the great pilot and in honor of his custom of not drinking liquor. Drink, gentlemen, to Col. Lindbergh, the world's greatest aviator."[80] Carranza enjoyed numerous cocktails at the Mint, including a "Lindy-Carranza Flying Pousse Café" made by Mitchell just for the occasion. It contained red, green and white layered liquors in honor of the Mexican flag. Amelia Earhart also stopped by the Mint Café during a short layover in El Paso on September 12, 1928, as she made her way

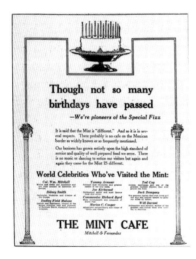

This advertisement highlights the many celebrities who traveled to Juárez to enjoy the drinks, food and entertainment at the Mint Café. *El Paso Evening Post*, May 30, 1928. El Paso Evening Post.

to Los Angeles. An article in the *El Paso Evening Post* detailed her visit, claiming that "altho [*sic*] the blood of a pioneering adventurer courses thru the veins of Amelia Earhart, she still remains feminine."[81] The article declared that Earhart "looked like an El Paso High school girl" who was "unaffected and gracious" while answering all questions with a smile.[82] That evening, Earhart dined at the Mint Café with Don Thompson, president of El Paso's Aero Club; it was reported that she drank only ice water. In the era of Prohibition, this type of public declaration was particularly important.

Beyond the recognition delivered by celebrity diners and drinkers, the Mint Café garnered attention in other ways at this time. In particular, Harry Mitchell expanded his market reach by broadcasting live radio shows directly from the Mint.[83] From a two-hundred-foot antenna from the new five-thousand-watt Juárez radio station, XEJ, listeners across the borderland could tune in during the evening to listen to the orchestra playing live from the dance floor at the Mint. Mitchell also served as vice-president of the International Order of the Bar Fly Trap No. 34, which was housed at the Mint Café. This organization, the second largest of the seventy-four traps worldwide, was quite popular in this era, when individuals prized memberships in fraternal organizations, women's auxiliaries and secret societies. According to the organization's rules, members had to be regular bar drinkers dedicated to the "uplift and downfall of drinkers at the bar."[84] The organization's handbook included rules such as, "members who bump their chins on the bar are subject to suspension for 10 days" and "back slapping after six drinks is forbidden entirely. At this stage, one's aim is often low."[85] And, by late 1932, as Prohibition was winding down, female drinkers insisted they have an auxiliary organization of their own. Bar-Butterflies Trap No. 1 was the first of its kind; it, too, was housed out of the Mint Café. Harry Mitchell expected that the repeal of Prohibition would witness an expansion of women's traps across the United States. According to the Bar-Butterflies Code, members would be permitted "to coo drinks from masculine members" but that women "with 'the weeps' over the boy friends will be penalized a round of drinks."[86] One rule, carried over from the Bar Fly's codebook, stated, "Nothing on the House, but the Roof."[87]

Yet even as the Mint became increasingly popular and well established, darker days lay ahead for Harry Mitchell. Dating back to 1923, Mitchell had entered into a partnership with Enrique Fernández in order to open the Mint, even though Fernández was well known in El Paso and Juárez for shady dealings and connections to illegal gambling and drug smuggling. Moreover, Mitchell had apparently loaned Fernández $24,000 in order to

" The Code of the Bar Flies, " *by* JACK DEAN

As we buzz around this old world of ours.
 Let's live as we fly on our way,
Goodfellowship is the rarest of flow'rs,
 Its fragrance will sorrow allay.
So, "Here's to The Bar Flies," "Good fellows all,"
 Give the toast with a loud ringing cheer;
May we always be "Bar Flies" until the last "Call,"
 Good hearted! Broad minded! Sincere.

Let's *Live* and *Let Live* sans malice or spite.
 From Neighbors' affairs keep afar.
The man who to-day's proclaimed in the right,
 To-morrow wears feathers and tar.
The "I.B.F's." all know Flies should be Free,
 Untrammed by Bigotry's Blight,
Pursuing our Happiness, pledging Liberty,
 Its our own God-given Birthright.

You've all seen a Bird fly. You've all seen a Horse-fly,
 You've all seen a House fly as well,
You've all seen your coin fly. You've all seen your kin fly,
 When you've had hard luck tales to tell.
But when you see a "Bar Fly" a true "I.B.F." guy.
 Give him "The Grip" with a welcome yell;
 Then both drink the bar dry,
 "Fill them up once more," cry,
 For a "Bar Fly" to be Bar Dry, Is Hell!

"The Code of the Bar Flies" by Jack Dean. *El Paso County Historical Society.*

help reopen the Tivoli Gardens Casino in Juárez.[88] It is believed that he used the terms of this loan agreement to remove Fernández as a partner in the Mint. Even so, Mitchell's association with Fernández tarnished his reputation for many years. In fact, in 1935, the family of Fernández sued Mitchell for $45,000 after Enrique had been shot and killed in Mexico City.[89] The lawsuit claimed that Mitchell had not fulfilled the terms of an earlier contract. Representing himself in court, Mitchell argued that he was intimidated into signing various agreements with Fernández and that he could not read Spanish. He was ultimately found not guilty on all counts.[90]

Making matters worse, in August 1931, Chihuahua state police arrested Mitchell and one of his bartenders, Rogelio Sánchez, as they sat in Sánchez's car in front of Mitchell's house after midnight. Both were charged with the possession and trafficking of an ounce of heroin. Mitchell immediately denied the charges and could not understand exactly why he had been arrested.[91] Two days later, the trafficking charges against Mitchell and Sánchez were dropped based on insufficient evidence. Instead, "the federal district attorney ruled that the charge should be possession of drugs…and turned the case over to the federal health delegation in Juárez."[92] Three weeks later, on receipt of warrants from Mexico City, the state police were ordered to arrest Mitchell and Sánchez once again.[93] Though Mitchell was vacationing in New York at the time, he was ordered to pay a 1,000-peso fine or spend fifteen days in jail.

It was also during August and September 1931 that other troubling matters for Harry Mitchell and the Mint Café surfaced. On August 28, the same day that Mitchell had been arrested, the mayor of Juárez closed the Mint Café due to walls that were deemed unsafe. Yet for undisclosed reasons, the mayor did not allow the Mint to be reopened after the walls had been fixed. While still closed, a fire broke out at the Mint on September 12. The *El Paso Times* reported, "While week-end throngs jostled each other on the Sixteenth of September Street in Juarez last night, fire of undetermined origin broke out in the basement of the Mint café, seriously damaging the dining room. Other parts of the building were damaged by heat, smoke and water."[94] Interestingly, it has been suggested that the Juárez Fire Department had been called but refused to fight the fire, citing insufficient water and equipment. Instead, it was the El Paso Fire Department that extinguished the blaze; a thankful Mitchell sent them $150.[95] A newspaper brief on September 16 reported that the fire's cause was spontaneous combustion in the Mint's basement.[96] In the end, no one was hurt in the blaze. Yet because Harry Mitchell was visiting friends in New York, he left his manager, Coleman A.

Feeney, in charge of the Mint. Feeney then made a fateful decision to lay off all of the Mint Café's employees while it was unopen for business.

Though Mitchell obtained the necessary permit to reopen the Mint on his return from the East Coast, he then faced a lawsuit brought forth by CROM—the Mexican national labor union—whose lawyers represented the employees who had been laid off by Feeney. Apparently, the layoff—even as it occurred while the Mint was being restored—represented a breach of contract. On June 6, 1935, after four long years of litigation, forty-five members of the union won a $22,000 judgment ($413,981 in 2020) against Mitchell and the Mint Café.[97] The union then demanded that, until the funds were paid in full, it should be given ownership of the business. The *El Paso Times* reported that "all interest in the Mint Café in Juárez, famous border eating and drinking place, was relinquished yesterday by Harry Mitchell after the café had been attached for a $22,000 judgment by the CROM Labor Union."[98] Harry Mitchell was quoted as saying: "It's all over. I turned it back to them this morning. I'm finished. I'm never going

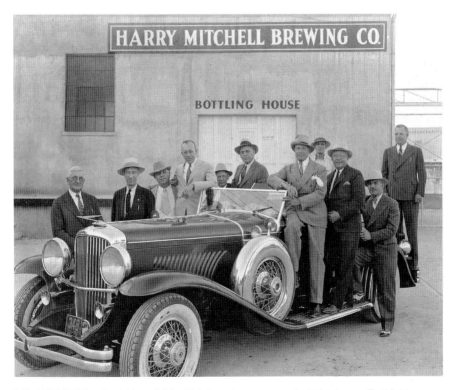

Mitchell (*third from the right*) established his brewing company in 1934, just as Prohibition came to an end in the United States. *El Paso County Historical Society*.

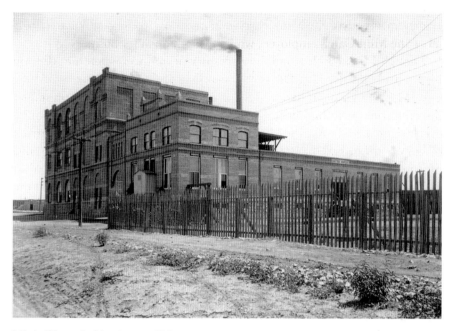

Mitchell brought his talents to El Paso, opening the Harry Mitchell Brewing Company in 1933. *El Paso County Historical Society.*

to be interested in anything else in Mexico if I can help it."[99] Mitchell was later asked if he would pay the sum, to which he stated, "They must think I'm crazy."[100] On June 20, 1935, the *El Paso Herald-Post* reported that the electric and gas services had been cut off and that the café would be sold at auction.[101] By all accounts, it appears that Harry Mitchell kept his word about never returning to Juarez. Instead, Mitchell devoted his time and money to building what would become the very successful Harry Mitchell Brewing Company in El Paso.

The story of the Mint Café begins and ends with Prohibition in the United States and the fortunes of the dynamic Harry Mitchell. The restaurant and bar came into existence to fill a need that could not legally be met in the United States as a result of the Eighteenth Amendment. The Mint then became a roaring success because of the vision of its owner. The combination of Mitchell's fine cocktails, his aggressive advertising, Carlsen's gourmet dishes and the boisterous live entertainment attracted the attention of those living in the borderland and celebrities far and wide. As Prohibition wound down across the border, the Mint Café's light began to fade, and Mitchell's entrepreneurial eye turned back to the United States and the potential that the repeal of Prohibition offered. Ultimately,

Mitchell and a friend stand beside a beer truck outside Harry Mitchell's Brewing Company, circa 1940. *El Paso County Historical Society.*

it should be no surprise that Harry Mitchell took out a quarter-page advertisement to announce the closing of the Mint Café. It read: "To all those wonderful folks from everywhere who helped make the Mint the finest, most distinguished place of its kind on the border, many, many thanks. THE MINT IS NO MORE!"[102]

PART II
FROM DOWNTOWN
TO THE SUBURBS

4

The Rise and Fall of Downtown El Paso's Lost Restaurants

MELISSA HUTSON

A city's downtown is like a richly layered book. The next time you walk through the downtown core of your city, think about what it can teach you. You will not only be looking at large buildings or bustling businesses. You won't only be watching rushed workers heading back to the office. You won't simply be observing the sights and sounds of traffic. By looking closely, you can see the lasting impact of the world on your city. For instance, by "reading" the landscape of downtown El Paso, one can understand how politics, economics, immigration and racial dynamics evolved in the city at large. And in the case of the lost restaurants of downtown El Paso, these factors significantly impacted the food that patrons ate.

In 1986, Cindy Wickham, manager of Como's Italian Restaurant, stated: "Many years ago, Downtown restaurants enjoyed a strong nighttime business....That was when people from the outlying areas of El Paso came downtown to shop, see movies and eat. Nowadays, these outlying areas have their own shopping centers, theaters, and droves of restaurants." Jack Maxon, who owned and operated Jaxon's for three decades, added, "All the action at night is out in the suburbs."[103] Wickham and Maxon, two of the many restaurateurs who moved their businesses out of downtown, were right. Due to a number of local and global factors, including urban sprawl, the global economic recession driven by high inflation rates in the

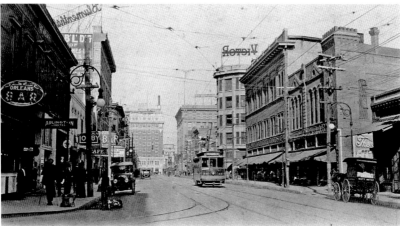

Top: Pioneer Plaza, February 1986. Hamburger Inn and Como's Italian Restaurant are visible next to the Plaza Theater. The theater was restored in 2006. *El Paso County Historical Society*.

Bottom: San Antonio Street at South Stanton Street. Electric streetcars were widely used in El Paso in the early twentieth century. *El Paso County Historical Society*.

Downtown El Paso skyline, circa 1930. *El Paso County Historical Society.*

late 1970s, the depreciation of the peso in the early 1980s and a 14 percent unemployment rate in El Paso in 1982, downtown restaurants closed at an alarming rate beginning in the 1980s. According to one study conducted in 1981, 31 percent of El Pasoans were eating out less compared to previous years.[104] Echoing Maxon's statement, families that did eat out chose to visit "family-friendly" restaurants within thriving suburban areas. In the first eight months of 1985 alone, twenty-six downtown restaurants closed their doors. Nevertheless, the story of El Paso's downtown restaurants was not always one of decline. In the early to mid-twentieth century, downtown restaurants thrived, and many living El Pasoans fondly recall day trips on the streetcar to visit movie theaters, stores and restaurants lining the streets. One could write an entire book on the lost restaurants of downtown El Paso, so this chapter is not a comprehensive history of these establishments. Instead, the following pages offer brief snapshots of some of the area's most memorable restaurants, highlighting the factors that influenced the food they served.

CULTURAL INFLUENCES ON DOWNTOWN CUISINE

To understand the development of restaurants in downtown El Paso in the late nineteenth and early twentieth centuries, a brief description of immigration to the area is necessary. It should be noted that this chapter will focus on two groups of immigrants, Chinese and Mexican, though many others immigrated to the region at this time.[105] The Treaty of Guadalupe Hidalgo divided Paso Del Norte (the region consisting of present-day El Paso, Texas, and Ciudad Juárez, Mexico) along the course of the Rio Grande in 1848. After 1848, Euro-Americans immigrated at increasing rates to the region, establishing businesses in what is now downtown. Though Mexicans continued to cross the river as they had for centuries, the United States prevented them from securing resources, which remained vital to their economic well-being, in the newly conquered land.[106] A dynamic rooted in the racially charged ideas of Manifest Destiny also emerged between Anglos and Mexicans in El Paso. Monica Perales states, "Before long the massive wave of capitalist development and subsequent economic explosion of El Paso cast the majority of Mexicans in the region into low-paying wage work."[107] Once an area unencumbered by an international boundary, El Paso became a gateway for Mexican immigrants entering into the United States at the turn of the century.[108] In 1881, El Paso became more interconnected with the rest of the United States and Mexico than ever before as railroads traversed the city. This further added to the racial milieu of the area because approximately 1,200 Chinese laborers helped forge the Central Pacific and Southern Pacific Railroads. Several hundred Chinese immigrants remained in El Paso and created El Paso's Chinatown.[109]

These dynamics directly influenced the emergence of restaurants downtown at the turn of the century. Early El Paso resident Leigh White Osborn, who lived on Myrtle Street in downtown for many years, described a vibrant Chinese community that owned and managed several thriving businesses. She stated: "People seldom ate out except to go to the English Kitchen—a Chinese Restaurant—where we went after the theater or dances. All other restaurants were Chinese."[110] Indeed, Chinese residents operated many of the establishments serving late-night dining in El Paso. Socialite Mrs. Frank H. Seamon told an *El Paso Times* reporter that the cosmopolitan thing to do was to "see a play at the old Myer Opera House and [go] afterwards for supper at the English Kitchen."[111] In the 1906 El Paso City Directory, fourteen out of the thirty-nine restaurants listed were Chinese

South El Paso Street, circa 1870s. *El Paso County Historical Society.*

restaurants. The most popular were the English Kitchen, the Eastern Grill, the American Kitchen and the Silver Grill. The English Kitchen, located at 106–108 San Antonio Street, advertised itself as the "most handsomely furnished, the cleanest, and the coolest place in the city to eat your meals. The only restaurant in the city with private booths."[112] The many proprietors of the English Kitchen over the years included Doc Sing, Mar Ming, Mar Chew and Mar Ben, who was known as the unofficial mayor of Chinatown. Mar Ben owned the Empress Theater at 214 South El Paso Street for a few years after 1914, and he and his brother Mar Chew also owned and operated the Eastern Grill at 123 South El Paso Street. This restaurant was located on a block of buildings with several other Chinese restaurants, including the El Paso Grill, the Star Shop House and the American Kitchen. On April 1, 1891, the *Commercial Review,* a listing of local businesses, recommended the American Kitchen Restaurant, owned by Bob Chin Wo, because it served delicious foods at moderate prices.[113] In the early years of the twentieth century, however, the number of Chinese restaurants owned by El Paso's Chinese residents dwindled, as did the city's Chinese population.

Some of El Paso's Mexican residents also opened restaurants downtown, but these establishments often went unnoticed in the media. One historian writes that despite El Paso's closeness to the Mexican border and the growing number of Mexicans living in town, local publications recommended

Myar Opera House, artist's conception, circa 1890. *El Paso County Historical Society*.

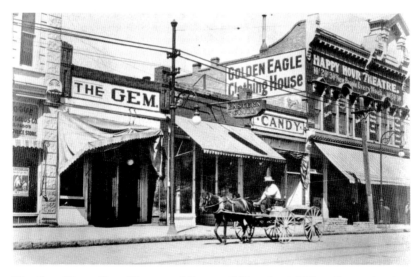

The Gem, Happy Hour Theatre and Eastern Grill on South El Paso Street, circa late nineteenth century. *El Paso County Historical Society*.

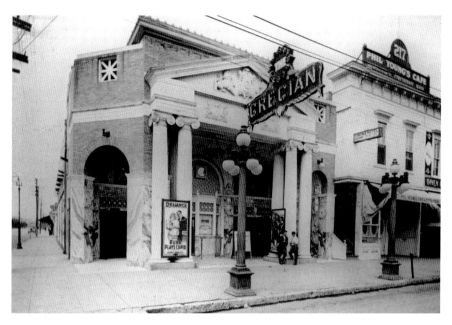

Grecian Theater, St. Simona Hotel and Phil Young's Cafe & Oyster House at 219–221 South El Paso Street, circa 1918. *El Paso County Historical Society.*

restaurants with European influences and "refined" dining.[114] For instance, the *Commercial Review* excluded Mexican restaurants in its compilation of best places to eat in El Paso. Instead, it championed establishments that served "first-class" dishes such as oysters and birds, like Phil Young's Café and Oyster House, located at 217 South El Paso Street, where patrons ate after a night on the town.[115]

Nevertheless, Mexican restaurants eventually flourished in downtown El Paso. One of the earliest and most prominent was Mexico Restaurant. The establishment opened in December 1914 at 314 South Oregon Street under the ownership of Jose J. Sanchez and Jose Castillo. In 1932, it moved into the Toltec Building, at 717 East San Antonio Street, where, shortly thereafter, it was sold to W.P. Casarez and his wife. The couple was greatly concerned with constructions of Mexican identity and advertised their space and food as existing "in a typical atmosphere of Old Mexico." According to one advertisement, the "expert native chefs with 18 to 24 years' experience with this restaurant prepare genuine Mexican foods which are served to you by our waitresses attired in the typical native costume of the China Poblana." They also advertised their tortillas, which were "made by hand in true Mexican style, by use of the 'Metate' in the

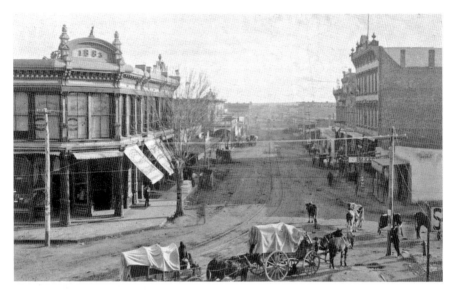

South El Paso Street, circa 1886. *El Paso County Historical Society*.

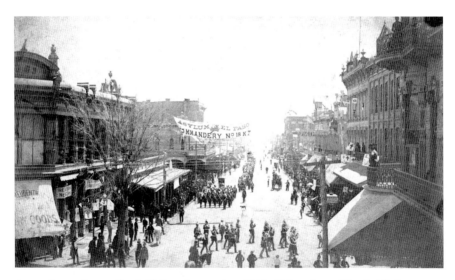

A parade marches on South El Paso Street, circa 1900. *El Paso County Historical Society*.

tortilla shanty in our dining room and served hot from the griddle to your table."[116] In 1948, Mexico Restaurant was purchased and remodeled by El Paso restaurateurs Leo Collins, his brother-in-law Willie Terrazas and Felipe Rosales and reopened as the second location of Leo's Finer Foods.

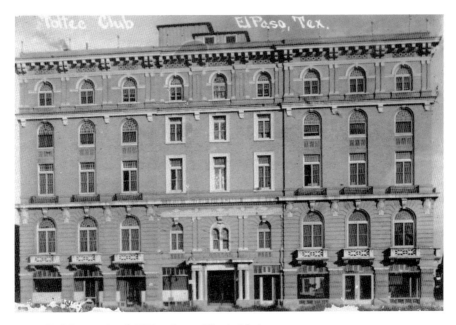

Toltec Building, undated. *El Paso County Historical Society.*

Collins and Terrazas opened the first Leo's Finer Foods at 1901 East Yandell in 1946, and by 1953, they had four locations throughout the city: 5103 Montana, Cotton at Yandell, 717 East San Antonio Street and 7872 North Loop in Tigua. In the 1980s, the franchise peaked with ten restaurants, all managed by members of the Terrazas, Rosales and Collins families.[117] Remembering his beginnings in El Paso, Terrazas told reporters that in the 1940s "El Paso had only four Mexican restaurants," and he decided "what this town needs is a good Mexican restaurant....My grandmother, Panchita Terrazas, came up with the recipes."[118] Although Leo's Finer Foods located in the Toltec Building moved to 315 East Mills Avenue in the 1960s and all of the downtown locations eventually closed, the next generation of the Leo's empire is still going strong. Leo's Mexican Food Restaurant is still open at 7520 Remcon Circle, and Guillermo "Memo" Avila, nephew of Leo Collins and Willie Terrazas, established one of the most successful Mexican restaurants in El Paso: Avilas at 6232 North Mesa.

DOWNTOWN RESTAURANTS IN THE MID-TWENTIETH CENTURY

Leo's Finer Foods was one of the few downtown restaurants to survive the war years in the borderland. The scarcity of staff and food resources placed a huge strain on businesses, and several restaurants appealed to El Pasoans to understand their plight and ask for support. After the outbreak of World War II, several downtown restaurants grouped together to release the following statement:

> *So YOU wanted steak today? And you wound up with a vegetable plate! Well, that's war. Maybe your favorite restaurant would have had steak for you today if they had been able to buy it. Maybe they had the ration points carefully counted out so they could serve you a tasty T-Bone—and maybe there just wasn't any steak to be had. That happens often in the restaurant business these days. Foods are scarce, as you well know from your own buying experience. And food shortages, coupled with scarcity of new equipment and lack of help makes the restaurant business a real headache! Yet the restaurants of El Paso are carrying on the best they know how; they're concentrating on one idea; To give you each day the best foods they can get, properly prepared, wholesome and satisfying. When Corporal Hitler and his pals have been licked, we'll have steak for you every day if you want it![119]*

In the midst of war, several downtown restaurants marketed their foods and services to soldiers stationed at Fort Bliss. The Wonder Café, located at 601 North Stanton Street, opened on January 10, 1940, and marketed its "Good coffee at Reasonable Prices" to soldiers and their families.[120] The restaurant was co-owned by Orville Worley and George Knight, a popular restaurateur. Another restaurant, the Best Café, located within the First National Bank Building at 103 North Oregon Street, was particularly popular after it opened in 1941. Andrew Beys, the proprietor, invited soldiers from Fort Bliss to visit and enjoy a taste of home, stating: "Food served at the Best Café is superb. While there is a scarcity of foodstuffs and we cannot get everything we'd like to have, no stone is left unturned to get the things that will please our customers....We want our boys to feel at home."[121] While the restaurant remained in operation successfully throughout the war years, it eventually closed in 1948.

Mexican restaurants and steakhouses fared well in downtown El Paso in the decades after the war. The number of steakhouses in El Paso grew

tremendously, so much so that an *El Paso Times* article debated labeling the city as a "Steak and Potatoes" kind of town.[122] The Branding Iron, located at 606 North Oregon, was one of El Paso's most prominent steakhouses. Located near the El Paso Public Library, the restaurant operated out of a quaint shopping center called La Villita. Opened in the summer of 1971 by Neal Franklin, it was later owned and operated by Carmen Suriano. In addition to serving steak, lobster, shrimp and more, the restaurant provided visitors with historical accounts of the Old West, a display of 480 branding irons from across the United States and "unsolicited testimonials [of the] 'superior recuperative reproductuous [*sic*] powers' of eating at the Branding iron plus an interesting array of information on the history of branding."[123] In 1978, a *New York Times* journalist listed it as the first place to visit on a tour of the border, writing: "The Branding Iron…in a restored Old Town–like shopping mall called La Villita serves beef in a red-plush setting dotted with branding irons. Its menu tends to be cutesy ('New York strip buddied with french fries') but portions are generous and cooked as requested, and a salad bar offers a wide variety of greens, beans and other fixings. Prices range from $2.50 for a lunchtime sandwich to $6.75 for dinner steaks."[124] The Branding Iron became a discotheque in the late 1970s and closed in the early 1980s.

Franklin, original owner of the Branding Iron, was the first person to receive a mixed-beverage permit in Texas since before the outbreak of World War I.[125] The vestiges of Prohibition reverberated through Texas for decades after the Eighteenth Amendment was repealed. Even today, Texas has one of the highest proportions of dry counties (a county that

Crawford House and La Villita Village on the 600 block of North Oregon Street in 1983. *El Paso County Historical Society.*

prohibits the sale of any alcohol) in the United States. When the Volstead Act was repealed on December 5, 1933, Texans voted on an amendment prohibiting "open saloons" and gave each county the option to prohibit all alcohol. Between 1933 and 1971, it was illegal to sell liquor by the drink in any establishment, although restaurants could sell beer and wine by the glass. In 1959, the Texas Supreme Court ruled that certain cities within a dry county could consider themselves "wet," but it was not until 1961 that the Liquor Control Board (known now as the Alcoholic Beverage Commission) licensed private clubs.[126] Restaurants, hotels and motels established "private clubs" on their premises, allowing people to become "members" for a night and have liquor by the drink. El Paso native and former state senator Joe Christie called these private clubs "hypocritical" and led legislative efforts to allow liquor by the drink in Texas. The "Open Saloon" Bill passed in 1971, and Christie became the "father of liquor by the drink in Texas."[127] With the assistance of Senator Christie, the Branding Iron was one of three establishments in El Paso that received a mixed-drink permit on June 1, 1971. It received one of only twenty permits issued that first day in Texas. For the first time in over fifty years, El Pasoans were able to enjoy liquor in local restaurants without obstacles.

A PERIOD OF DECLINE

By the 1980s, patrons had veered away from El Paso's downtown restaurants. In 1986, the proprietors of Chicken Plus posted a sign on its door: "Chicken plus has become yet another victim of apathy in the downtown area. We will remain closed until further notice."[128] This sign reveals the anger and frustration felt by restaurateurs about the lack of patronage and growing rent prices. George Thomas, a well-known property manager, builder and restaurateur, opened Chilos Restaurant in 1975 and closed it ten years later. Thomas told reporters that his restaurant never made any real profit, and in the 1980s, it began losing $1,000 a month. While many restaurants were busy enough during the lunch hour to perhaps break even, many El Pasoans who worked downtown chose to spend their evenings and weekends in other areas. Susan and Brad Cooper purchased the spaces that housed Jaxon's and the Stanton Room, both owned by Jack Maxon, in 1984 (see chapter 9).[129] Jaxon's opened in

Station Street, looking south, 1988. A.B.C. Bank (Southern Pacific building), Hotel Gardner, Brown Bag Deli, Lucy's, Cooper's and the Stanton Room are visible. *El Paso County Historical Society.*

1973 as a bar and grill, and the Stanton Room was El Paso's premier fine dining, French restaurant. The Coopers opened an establishment named Cooper's in the summer of 1984 and closed it just two years later on June 20, 1986. Susan Cooper told reporters that Cooper's was forced to close because the "old building and the overhead killed us." She had closed the Stanton Room the year before for similar reasons.[130]

One of El Paso's longest-lasting restaurants, Sol's Barbecue, first opened in 1939 at 601 North Stanton Street, was forced out of downtown El Paso in 1986 and closed its doors twenty years later. On September 20, 1970, the *El Paso Times* declared Sol's Barbecue the place "where the elite eat," because owner Sol Metzgar served the downtown business elite "40 dozen buns and 250 pounds of beef every day."[131] Metzgar was remembered fondly by El Pasoans as a master in barbecue and "as a generous man who helped others but never sought the limelight."[132] He retired in 1968 and sold the restaurant to Armando and Hillary Herrera, who successfully managed it until 1986. Surety Savings bought the property to lease the block for a new bank, and high rent prices prevented the Herreras from leasing another space downtown. The building was demolished, and the

Demolition of Sol's Barbecue, Stanton Street at Wyoming Avenue, December 3, 1986. *El Paso County Historical Society.*

restaurant was moved to 9707 Montana, in east El Paso. Sol's Barbecue closed for good on July 31, 2006.

Cooper's and Sol's Barbecue are only two examples of restaurants that left downtown El Paso as the area experienced decline in the late twentieth century. Like many metropolitan areas in the United States, El Paso's downtown core fell into disarray as residents ventured into the suburbs. Though several successful efforts have been made to revitalize the area, many historic buildings remain in disrepair, and businesses have had difficulty establishing themselves here.

El Paso's downtown is a richly layered book, and the history of its lost restaurants fills its chapters. To observe the divine architecture of its historic buildings is to witness El Paso's moment as a thriving metropolis during the first half of the twentieth century. To see people walking down its streets is to see an amalgam of cultures that have evolved in the region for generations. To watch traffic navigate crowded streets under construction is to behold a desire by many to renew downtown to its past glory. And to eat downtown today is to partake in a legacy of cuisine influenced by politics, economics, immigration and racial dynamics. Indeed, that legacy stems from the world's influence on the city.

5

Fred Harvey and the Legacy of the Harvey Girls

PRES DEHRKOOP

Less than a mile from the international boundary in downtown El Paso, a picturesque train station has served travelers for over a century. Framed by the Rio Grande, Juárez Mountains and historic downtown buildings, the Union Depot remains an architectural icon. Few El Pasoans, however, remember that the depot also welcomed patrons to one of Fred Harvey's restaurants for forty-two years. The national chain offered efficient service, delectable dishes and a quaint ambiance. This is the story of Fred Harvey's initial vision and the hard work done by the women who made this restaurant chain one of a kind.

Fred Harvey was seventeen years old in 1853 when he arrived in New York City from London with ten dollars in his pocket. His first job was at Smith & McNeil's restaurant as a dishwasher. He learned the importance of fresh food and hospitality and worked his way up. Loving good food and travel, he headed to New Orleans. Not finding an opportunity that he thought he would enjoy, he went on to St. Louis, where he experienced some success. He and a partner became owners of Merchant's Dining Saloon and Restaurant, which was located where the Gateway Arch stands today. As the Civil War approached, his partner absconded with their savings. Harvey was now broke.[133]

Harvey then worked several jobs with the railroads when he was given the opportunity to join the Chicago, Burlington and Quincy line as a general

agent.[134] During this time, he dreamed of opening a place where passengers could stop to enjoy good food. Tenacious as he was, Harvey suggested to the rail line how this could happen. They passed on his plan and suggested that he take his idea to the Atchison Topeka & Santa Fe (AT&SF). This line accepted Harvey's vision, cementing a collaboration that lasted nearly a century.[135] Harvey established his first eatery, a lunch counter at the AT&SF depot in Topeka, Kansas. It was such a success that they soon had to expand. He then borrowed money to purchase a restaurant and hotel in Florence, Kansas. Harvey's enterprise treated guests to the freshest food at a reasonable price. Bread was baked daily and sliced three-eighths of an inch thick, and pies were cut in fourths. He also ensured that his menu did not go stale. Indeed, he changed it every four days. Insisting on perfection and making each one of his eateries follow the same code, Harvey frequently visited each location to inspect them. Upon his death on February 9, 1901, Harvey and his family owned and operated fifteen hotels, forty-seven restaurants, thirty dining cars and Ferry Food Service across San Francisco Bay. Harvey's children and grandchildren built on his enterprise, expanding the company more than he possibly could have imagined.

How did the Harvey Girls enter into his vision? In Leavenworth, Kansas, Harvey had a friend and neighbor named Tom Gabel. Harvey invited Gabel to accompany him as he traveled to Raton, New Mexico, to visit one of his restaurants. On arriving, they noticed the waiters wearing soiled clothing, as they had been out on an all-night spree. Furious, Harvey fired them. Gabel then suggested that Harvey hire women.[136] Harvey found the idea appealing, so he told his friend to go back to Leavenworth and make it happen. Harvey then said he would put Gabel in charge of the restaurant in Raton. Gabel was taken aback, as he had no experience managing restaurants. Nonetheless, he accepted the offer and ran the restaurant for several years, hiring waitresses they called the Harvey Girls.[137]

Advertisements sought single young women, eighteen to thirty years of age, with "good character" who were also "attractive and intelligent." The wages were $17.50 a month and included room and board. The women, if hired, went through extensive training and signed a three-, nine- or twelve-month contract, promising not to marry during that time. The girls had a "Harvey Girl Training Guide," laying out the rules they were expected follow. It was all to be done "The Fred Harvey Way." The uniform was a long-sleeve black blouse, long black skirt (always eight inches from the floor), a long white apron and a white Elsie collar always to be spotless. No makeup, jewelry or perfume was allowed, and the girls were inspected before they

went on their shift.[138] The girls, mostly from the eastern and midwestern United States, were excited to see the American Southwest. They lived in a dormitory watched over by a house manager. They needed permission to date and had a strict code of conduct. They had to abide by curfew and be in their rooms by 10:00 or 11:00 at night. The work was difficult, as they made sure everything was in order when the trains arrived. They prepared tables, setting them with linens, china and silver. Then they had to serve passengers and train crews in record time several times a day. In their spare time there were many chores to do, including shining silver and the large coffee urns. A Harvey Girl learned that her customers were her guests and she was the hostess. Harvey Girls considered it an honor to serve and were very proud to carry on the tradition. Over the years, at least 100,000 women worked as Harvey Girls.

On January 17, 1906, the Harvey House chain was granted a concession to open a restaurant and lunch counter at the El Paso Union Station Depot.[139] The company also opened a curio shop, barbershop, newsstand and bar in the depot. It was reported in the *Albuquerque Morning Journal* on January 25, 1906:

> *The new café in El Paso Union Depot is to have a seating capacity of one hundred six people and to be one of the largest and best appointed on the system. The café will feed at least twenty-two trains per day. The Harvey House will furnish the supplies for dining cars and all private dining cars passing through the El Paso Gateway. G.E. Pellow of Trinidad traveled to Kansas City to purchase supplies and furnishings for the Harvey System in El Paso.*[140]

On February 28, 1906, the El Paso Union Station Depot, built by Daniel Burnham of Chicago, opened to a celebrating crowd of ten thousand people.[141] The Harvey House area was used for dancing that evening, and on April 24, 1906, the Harvey Lunchroom opened. It was reported in the *El Paso Times*: "The Harvey lunchroom opened at the union depot. It was the handsomest dining room in the west and the finest depot dining room in the entire country."[142] Unfortunately, there seem to be no pictures of the dining room interior or lunch counter that might show us what it looked like (at least none that the author has seen). The *Herald Dispatch* on April 25, 1906, printed an article, "Dining Hall at Union Station Is Artistic Gem," describing the beauty of the remarkable restaurant and lunch counter. Fumed oak paneling graced seven-foot walls, and stained colorful glass

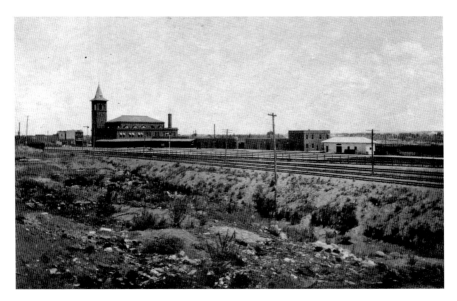

El Paso Union Depot, circa 1915. *El Paso County Historical Society.*

appeared in all of the windows. Swinging glass doors with stained-glass panels separated the dining room from the pantry. Both round and square tables were used, electric lamps placed on each table sporting art glass shades. The lunch counter, which was open twenty-four hours a day, was made of fumed oak and marble. Revolving chairs completed the inviting area for those who wanted a fast meal. Patsy King remembers how her father, Chris Fox, would take the family to the Harvey Restaurant: "The tables were filled with imported Irish Linen tablecloths and Sheffield flatware from England inscribed with 'Harvey House' on each piece. A silver coffee carafe or teapot graced each table so cups could be filled as needed. A crystal carafe of cool water was always available."[143]

El Paso's employees experienced a slightly different working environment from the employees at other Harvey locations. No dormitory was available for the El Paso Harvey Girls. Instead, many of the local girls lived in apartments near the depot or in boardinghouses. The uniform worn by El Pasoans also varied from the typical uniform worn in other locations, due to the arid climate. Lillian Mendez Medina, who was only fifteen years old when she worked as a Harvey Girl in the 1940s, recalls wearing a white blouse, white skirt to the knee, white stockings and shoes and a black bow tie. Her sister Bertha Mendez, who bussed tables, wore a white shirt, brown pants and shoes and a hat.[144]

UNION STATION LUNCH ROOM FRED HARVEY, El Paso, Texas
Sunday, September 13, 1931 J. T. VERLIN, Manager

Relishes and Appetizers

Radishes 10 Green Onions 10 Ripe or Green Olives 20 Melon Supreme 20
Fruit Cocktail 35 Dill Pickles 10 Tomato or Sauerkraut Juice 15
Imported Sardines 50 Pascal Celery 20 Crab Meat or Fresh Shrimp Cocktail 45

Soups

Cream of Chicken, a la Reinne 20 Consomme Julienne 15
Essence of Tomato, Hot or Cold 15 Clam Bouillon 15

Seafoods

Boiled Columbia River Salmon, Parsley Sauce _____ 60
 Fried Filet of Halibut, Tartar Sauce _____ 55
 Broiled Sea Bass Steak, Maitre D'Hotel _____ 55
 Fresh Gulf Shrimp, a la Newburg, en Casserole, Trilby Toast _____ 60

Today's Suggestions

Terminal Vegetarian Dinner with Poached Egg _____ 50
Boiled Smoked Ox Tongue with Mashed Rutabaga _____ 45
 Peach Fritters, Cocoanut Custard Sauce _____ 35
 Combination Plate, Cold Roast Pork on Whole Wheat Bread,
 Raspberry Jam, Combination Salad and Drink _____ 85
 Sweetbread Patties, Victoria, Asparagus Points _____ 60
 Grilled Veal Porterhouse with Rasher of Bacon _____ 60
 Fried Spring Chicken, Country Style, Cottage Fried Potatoes _____ 90
 Omelette with Home-Made Watermelon Preserves, Buttered
 Whole Wheat Toast _____ 45
 Roast Prime Ribs of Beef, au Jus, Fried Hominy Grits _____ 65

Steaks, Chops, Poultry

Loin Butt Steak 75 Sirloin Steak 1.50 Tenderloin Steak 1.40
Pork Chops (2) on Toast 60 Broiled or Fried Spring Chicken (Half) 90
Chicken Fried Steak, Fermiere 65 Hamburger Steak, Tomato Sauce 50
Calf's Liver and Bacon 55 French Lamb Chops 60 Baked Pork and Beans 30

Hot Weather Suggestions

Cold Ham or Tongue, Potato Salad 45 Assorted Cold Cuts 65
Chilled Salmon 50 Cottage Cheese with Chives, Rye Bread 25
Sliced Chicken, Combination Salad 90 Cold Roast Prime Ribs of Beef 70

Vegetables

Cauliflower, Polonaise 15 Fried Egg Plant 15 Corn, per ear 15
Fresh String Beans 15 Okra and Tomatoes 15
Potatoes—Mashed or Boiled 10 New, Persillade 20 Au Gratin 20
 French Fried or Hashed Browned 15

Salads

(Served with French or Paprika Dressing)
Combination 25 Sliced Tomatoes 25 Head Lettuce 20 Fruit Supreme 40
Sliced Cucumbers 25 Chicken 45 Fresh Shrimp 50 Potato 15
Beet and Egg 20 Pineapple and Cottage Cheese 20 Crab Meat 50
 Chef's Special Combination Salad, Thousand Island Dressing 40
Dressings—Roquefort Cheese 25 Thousand Island 15 Mayonnaise or Durkee's 10

Sandwiches

(Served on Toast if Desired)
Bacon and Tomato 30 Boiled Ham 15 Sliced Chicken 50
Chicken Salad 40 Special Club (Three Layers) 65 Ox Tongue 25
Swiss Cheese 25 Goose Liver 20 Corned Beef 20 Brick Cheese 15
Peanut Butter 15; with Jelly 25 Imported Sardine 25 Baked Ham 20

Desserts

Creme de Menthe Punch 15 Walnut Cake 15 Parisienne Parfait 25
Banana Pudding Souffle, Cherry Sauce 15 Fruited Gelee, Whipped Cream 15
Chocolate Ice Cream 20 Vanilla Ice Cream 15 Pineapple Sundae 20
Manhattan Glace with Cherries 25 Biscuit Tortoni 20 French Macaroons 15
Fresh Peach Ice Cream 20 Sliced Fresh Peaches 25
Cantaloupe, Half 15 Cup Custard, Whipped Cream 15 Peach Short Cake 25
Iced Watermelon 20 Sliced Pineapple 20
Persian or Casaba Melon 25 Honey Dew Melon 25
Pies—Green Apple 15 Fresh Rhubarb 15 Boston Cream Pie 15
Cheese—American 20 Imported Swiss 25 Roquefort 25 Cottage Cheese 15

Coffee, Tea, Etc.

English Breakfast, Ceylon, Orange Pekoe, Oolong or Young Hyson Tea, Pot 15
Milk 10 Half and Half 25 Buttermilk 10 Horlick's Malted Milk, Glass 20
Coffee 10 Postum 10 Cocoa, Pot 15
 Bread and Butter Service 10c per person
 Traveler's Box Lunch 50 Special Lunches to Order
Not responsible for loss or exchange of wearing apparel or other personal effects

Harvey Lunch Room menu, 1931. *Harvey Girls of El Paso, Texas Archives.*

The experience left lasting impressions on former employees of the Union Depot location. Aurora Gooch Arriola worked as a cook at the restaurant in the 1940s and raised her family across the street from the depot. The Arriola family tells stories of soldiers from the troop trains being fed by the Harvey Girls both in the dining room and on the trains.[145] Kelpie Ann Rainey Hughes was one of the original Harvey Girls to work at the depot in 1906. She came to El Paso from the Texas Hill Country. Kelpie answered the recruitment ad and persuaded her parents to let her travel to El Paso. She worked at the depot for several years before marrying.[146] Jose Ornales, who worked at the Harvey House in El Paso in the 1940s, made salads. After several years, he was transferred to the Bright Angel Lodge at Grand Canyon in Arizona. After working at this Harvey House for several years, he returned to El Paso and opened two restaurants. He stated, "I could never leave the good food business, and everything I learned about the restaurant business was from being a Fred Harvey employee."[147]

The Harvey House in El Paso is but a distant memory for many. You can still walk on the original tile floors in the building, but the area where the dining room and lunch counter welcomed patrons is no longer accessible to the public. Today, one may be discomforted when learning about the history of the Harvey Girls. It is unthinkable to expect anyone presently working at a restaurant to forgo a romantic relationship or meet curfew to keep a job. Yet the legacy of the Harvey Girls should be placed in proper context.

Harvey Restaurant employees in El Paso, circa 1946. *KansasMemory.org*.

Many former employees fondly remember their experiences and contributed to a culture of hard work during a bustling era. The work gave them an opportunity to travel far from home and settle throughout the United States. Former employees are proud to have been part of this elite establishment. (The El Paso location closed its doors in 1948.) As such, in the spring of 2014, the Harvey Girls of El Paso, Texas, was formed to research, document and share the legacy of the Harvey Girls by giving speeches, presenting programs and gathering oral histories.

6

For Those of You with a Sweet Tooth

Elite Confectionary

Whether one was an everyday El Pasoan or a general in the Mexican Revolution, people with a sweet tooth traveling through downtown in the early twentieth century satiated their appetites by stopping at Elite Confectionary Candy Store. Elite was a special type of restaurant in El Paso that primarily sold sugar-filled snacks.[148] Nevertheless, it also served the purposes of a typical restaurant in that it created bonds and memories among the community.

The origins of Elite Confectionary date to March 1, 1898, when Richard T. Rogers opened Rogers Candy Store at 206 North Oregon Street.[149] At the time, El Paso was a small town with a population of about fifteen thousand, and the store was often advertised simply as "next to the post office," if a location was even mentioned at all. Its tenure, however, was short-lived. In the midst of a scandal of abandonment, separation and eventual divorce, Rogers sold the store to Edward S. Potter in February 1902 for $3,250 (about $97,000 in 2019).[150] Potter, an experienced candymaker from New York City, did not remain in El Paso very long. On May 15, 1902, he transferred his store to C.S. Pickrell & Company and then moved to Tucson, Arizona, to start up a new candy store.[151]

Whatever the reason for the quick sale, Clarence Pickrell, a confectioner, from Dallas, Texas, immediately went to work making his newly renamed store, Elite Confectionary, the "go to" place for El Pasoans to satisfy their sweet tooth. He advertised in both the *El Paso Herald* and *El Paso Times*,

indicating that he was the successor to Rogers Candy Company and E.S. Potter. The candy store became so well known that the advertisements often contained little more than the name of the store.

Meanwhile, on June 11, 1902, Richard Rogers and his former wife, Mary, reconciled and remarried. In January 1903, Rogers opened a new store, Rogers Candy & Manufacturing Company, in El Paso. In order to differentiate his new store from Elite Confectionary, he advertised his candy as "Original Rogers Candies." He may not have been as successful this time around; by early 1910, he had left El Paso to open Rogers Candy Company in Nogales, Arizona. It is just as well that he left when he did, because Pickrell & Company would soon expand with a vengeance.[152]

On August 14, 1910, the J. Calisher Dry Goods Company, a thirty-year-old department store in the Buckler Building, caught fire. Completed in December 1902, the three-story building at the corner of Mesa Street and Texas Street was destroyed. Less than one month after the fire, Elite Confectionary had already made plans to lease the soon-to-be-built two-story Buckler Building. On September 12, 1910, Pickrell signed a contract to lease the entire building for $1,900 per month ($51,000 in 2019) and intended for the confectionary to occupy most of the first floor. He planned to spend $25,000 on the store, with $15,000 of that expense planned for the soda fountain alone ($675,000 and $405,000 in 2019, respectively).[153]

When Elite opened the new store at 201 Mesa Street at Texas Street on March 16, 1911, over 3,500 people showed up during the four-hour celebration (nearly 10 percent of El Paso's population of about thirty-nine thousand). The following day, the *El Paso Times* described it as:

> *easily the most luxurious and elegant to be found in the west, and the new resort is quite the swellest* [sic] *thing in confectionaries to be found in the great state of Texas. The new store has over 4200 square feet of space, with a capacity of 230 persons at one time. The decorations are in green, gold and white, with the exception of the gorgeous fountain. Elegant little booths are arranged around the sides of the store, the wood work* [sic] *of the booths being green to correspond with the color scheme. A balcony with a capacity nearly that of the main floor is fitted up with tables and chairs, and on the main floor tete-a-tete chairs, for just two, are grouped around in elegant profusion. In the middle of the reception portion of the main floor is a water fountain, with a moss bowl in the center into which a number of big green frogs throw as many tiny streams from their hiding place amid evergreens and hyacinths on the edge of a pool. The soda fountain, however,*

the finest of its kind in the country [sic], *if not in the United States, was made to special order and is a magnificent monument of white marble, onyx, real bronze and multicolored art glass....The art glass canopy of the fountain, which is supported by four onyx pillars, is one mass of color through which effulgent rays float in beatific profusion.*[154]

The *El Paso Herald* added:

Throughout the place the crowds admired the beauties of the place. The lovely pergola with its grapevine clusters and its dainty lights shedding their tints through immense bunches of crystal grapes, proved an immediate favorite. The balcony, apparently swinging from gold chains, afforded another cosy [sic] *retreat....The fountain itself is the star feature of the place. The counter is white marble with green marble base. Surmounted by an art glass and bronze canopy that is a wonder in workmanship and beauty....*[The factory takes up] *the entire 7500 feet of floor space in the basement...and this factory will be open every day to visitors.*[155]

Perhaps Elite Confectionary is best known as the setting of one of the most recognizable photos taken during the Mexican Revolution. During the conflict, which spanned the 1910s, rebels established headquarters in El Paso as a safe haven from the Mexican government. A lover of sweets, revolution leader Pancho Villa was a regular at Elite and had a penchant for the confectionary's ice cream baseballs. Joseph Young, a longtime Elite employee, concocted the baseballs around 1905. They were made with two flavors of ice cream, formed in a mold and covered in chocolate. They were then wrapped in foil printed to resemble a baseball.[156] "In May 1911," David Romo writes, "the celebrated El Paso photographer, Otis Aultman, took the well-known photograph of Pancho Villa and Pascual Orozco sitting stiffly next to each other at the Elite Confectionary....During the Battle of Juarez, they were coconspirators, but later they would become implacable enemies." Elite, then, like many downtown El Paso establishments, played a role in international affairs.[157]

On March 1, 1918, Frank Pickrell, Clarence's nephew and a co-owner, resigned his position as assistant manager. Young, who at this point had been with Elite for sixteen years, became the new assistant manager.[158] The management tried novel ways to attract customers. During the summer of 1919, Elite offered the performances of a jazz orchestra daily, both in the afternoon and in the evening. This tactic was tried again in September

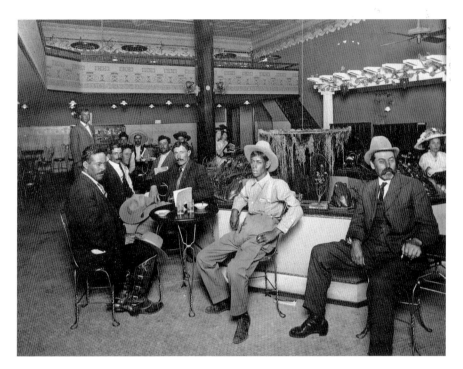

Otis Aultman photographed Mexican Revolution leaders Pancho Villa and Pascual Orozco (*both seated with hats on their knees*) at Elite Confectionary in May 1911. *El Paso County Historical Society.*

1922. This time, it was specifically targeted to teens returning to school and included dancing. On February 5, 1920, Elite started serving hot lunches from 11:30 a.m. to 1:30 p.m., Monday through Saturday, ostensibly for the downtown businessmen. Cold lunches, often referred to as "dainty lunches," were served daily, at all hours.[159]

In the 1920s, the heyday of Elite Confectionary in downtown El Paso came to an end. In September 1923, Pickrell tried to renew Elite Confectionary's lease on the Buckler Building, but Margaret Buckler, its owner, refused to abide by the terms of the lease. The original agreement in 1910 was a seven-year lease with an optional five-year extension. In 1917, Pickrell had signed a second seven-year lease with a rent increase and the same option of a five-year extension, so he anticipated a similar deal. However, Buckler did not honor the extension of the lease at $30,000 per year and instead leased the building to W.T. Grant Company, a woman's apparel store, for $42,500 per year ($450,000 and $638,000 in 2019, respectively). On July 27, 1925, Clarence Pickrell and Elite Confectionary filed a lawsuit against Buckler for

Buckler Building, 2019.
Kathy Pepper.

$107,650—$82,650 in actual damages and $25,000 in punitive damages (about $1.2 million and $370,000 in 2019, respectively).[160]

By February 1925, Elite Confectionary's managers had moved all business to its second location in central El Paso. In 1917, they had opened another confectionary at Cedar Street and Montana Avenue, about two and a half miles from downtown. It was known simply as the Five Points store.[161] On March 1, 1925, Young announced that he had purchased Elite. By December 1930, Elite had just ten employees, a far cry from its halcyon days in the 1910s and '20s. By January 1931, Elite was behind in its rent; in February, it was listed for sale; and in March, it went into bankruptcy. On April 17, 1931, forty-nine-year-old Joseph Young died after suffering from chronic nephritis and uremia (kidney disease) for several months.[162]

Today, most people purchase sweets at grocery stores or online. With the exception of ice cream shops and some specialty stores, restaurants dedicated solely to the manufacturing and sale of confectionary delicacies are relatively unheard of these days. Elite Confectionary was certainly a special institution in El Paso. Its allure of could satisfy just about anyone's appetite for sugar, even revolutionaries.

7
Hollywood Café

KATHY PEPPER

When conjuring images of ritzy, glitzy nightclubs of the 1930s and '40s, one typically thinks of New York venues such as the Cotton Club, Copacabana and Stork Club. One might envision the extravagant decor, live orchestra, floor shows consisting of singers and dancers and a dance floor to accommodate the club's patrons between acts. These descriptions also apply to El Paso's own Hollywood Café, located at 301 South El Paso Street. Opened in 1931, it had an eighteen-foot ceiling supported by Corinthian columns. The stained-glass windows and transoms allowed light to shine beautifully in this elegant club. Hollywood Café served patrons on the ground floor of the Merrick Building, erected in the 1880s. However, because of the club's popularity, the building was usually referred to as "the Hollywood Café building."[163]

After Congress repealed Prohibition, Hollywood Café set out in earnest to become the number-one entertainment hot spot in the region. In January 1934, one local newspaper announced that the newly remodeled Hollywood Café would soon reopen with "one of the best dance floors in El Paso."[164] Shortly afterward, the venue started advertising various acts appearing in its cabaret show. In addition to the floor acts, Hollywood Café employed "B-girls," young women who were paid to drink and socialize with the customers. These women were generally paid a percentage of the revenue from drinks the customers bought them. Unbeknownst to the customer, the drinks were usually watered down or nonalcoholic. Around this time,

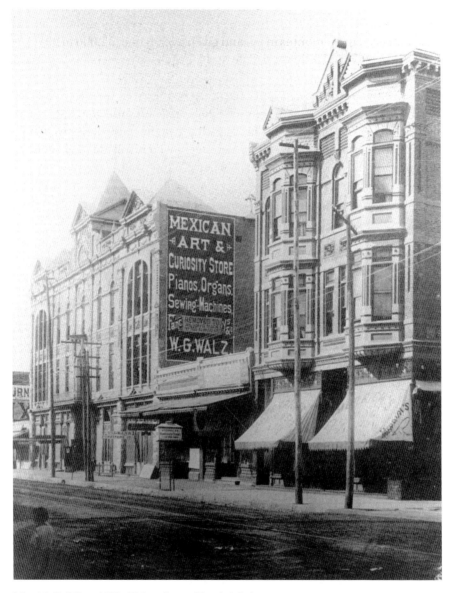

Merrick Building, 1892. *El Paso County Historical Society.*

several El Paso nightclubs, including Hollywood Café, also employed "taxi dancers," young women who danced with customers for ten cents a dance. This practice was banned in El Paso in early 1936.[165]

Perhaps because of the spectacle, Hollywood Café experienced its fair share of controversy. In 1934, a sixteen-year-old girl accused twenty-eight-

year-old Joe Jabalie, one of the managers, of aggravated assault. Jabalie was sentenced to six months in jail and given a $200 fine ($4,000 in 2019).[166] Over the next year, Hollywood Café and Jabalie made several appearances in El Paso newspapers, after police officers raided several cafés and bars and seized slot machines, marble boards and dice games. Some of the gaming devices were called "nickel machines," because they cost 5¢ to play (about $1.00 in 2019). The machine owners said they brought in about $500 (over $9,000 in 2019) per week, which was divided between the machine owners and business owners. Hollywood Café, as well as a half dozen other bars and cafés, was raided again three years later, also due to gambling.[167] Furthermore, in the early morning hours of December 1, 1935, a man was fatally shot after an argument over two 10¢ beers. Clarence Woolverton, the twenty-seven-year-old nephew of El Paso Police detective Captain W.C. Woolverton, had dinner with a buddy, Joe Amador, earlier that evening. Several hours later, they decided to have some beers before going home. When the bartender asked for payment, Woolverton complained that he had already paid, and he threw down 25¢ and hit the bartender. He left and returned to the bar almost immediately. This time, headwaiter Joe Barbery hit Woolverton. Woolverton again left but continued fuming all the way to his home, where he retrieved a handgun and once again returned to the establishment. Although Amador tried to prevent any additional violence, Woolverton shot and injured Barbery, a man he had been friendly with for ten years, before being shot by twenty-seven-year-old special officer Herman E. Dorsey. A grand jury declined to indict Dorsey for the death, but he was held on charges of allegedly not having a permit to carry a handgun. Those charges were eventually dropped, because he was entitled to carry the handgun in the commission of his duties as a special officer for Hollywood Café. Less than three years later, Dorsey was again in trouble with the law for pulling his weapon on two fellow special officers during a drunken argument.[168]

For the next twelve years, Hollywood Café stayed out of the public eye, at least as far as illegal activities were concerned. During this time, the business proved itself to be very civic minded. It sponsored the El Paso chapter of the American Red Cross, donated to the El Paso War Fund, encouraged the public to buy War Bonds at the café in order to "Stamp Out Tyranny" and supplied sandwiches to Smeltertown women on strike.[169]

However benevolent the managers were during this time, several of them started showing up in the news for less-than-savory activities. In April 1952, co-owners Jim Jabalie and Tony Salem, along with café manager

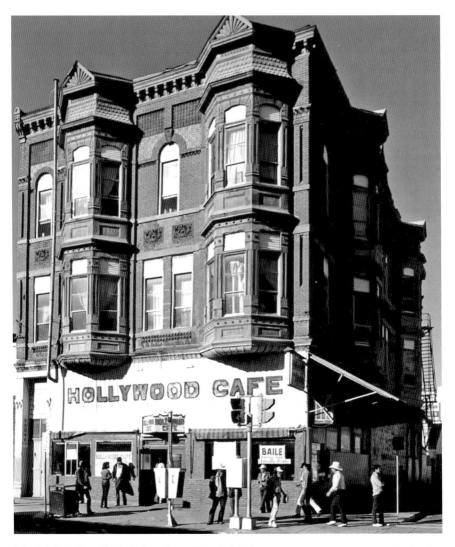

Merrick Building, 1989. *El Paso County Historical Society.*

Manuel Duran, were arrested for purchasing smuggled meat from Mexico. An eighteen-year-old man from Juárez named Jose Rodriguez-Hernandez would strap about sixteen pounds of beef to his body and then ride his bicycle across the international boundary, making several trips each day. In its records, the restaurant marked these purchases with the initials "H.M." The presiding judge in the case, R.E. Thomason, asked if that stood for "horse meat," but the young man claimed it meant "hamburger meat," even though he was initially accused of smuggling mostly expensive cuts of steak.

He said he purchased the beef in Juárez and then sold it in El Paso for 40¢ per pound. In 1952, hamburger meat cost about 57¢ per pound in El Paso and steak averaged about 74¢, so buying meat that much cheaper would give the café owners a considerable profit. Jabalie pleaded guilty to his role in the smuggling of 6,654 pounds of meat from Juárez during the previous year. The judge fined Jabalie and his manager $3,500 (nearly $34,000 in 2019), and each man received a four-month suspended sentence. Jabalie wanted a suspended sentence because he was afraid a prison sentence would lead to deportation to Syria.[170]

Hollywood Café may have been the place to go in the 1930s and '40s, but it steadily declined through the 1950s until it simply became known as a twenty-four-hour diner. The decline may have been caused by poor management or the general change in attitude about entertainment after World War II. Whatever the reason, around 1961, George Kahlil Haddad and Anis Balesh, both natives of Lebanon, bought the establishment. In 1967, Balesh paid $60,000 for the three-story Merrick Building. They converted the top two floors, which once served as the St. Charles Hotel, into apartments.[171]

In 1989, the Sunturians, a merchant organization, worked with the City of El Paso to revitalize downtown, specifically South El Paso Street. The city paid $27,000 to determine the cost of restoring the Merrick Building's 1887 façade, an effort estimated at $118,000. Converting the interior of the building into retail and office space and renovating the upstairs apartments would cost more than $680,000. In August 1991, Balesh closed the Hollywood Café, selling everything, from Melmac dishes to booths, in preparation for the historic renovations to the Merrick Building's exterior and the conversion of the interior into a mini mall. Shortly thereafter, work crews began the transformation. Nevertheless, the heyday of the vibrant, yet controversial Hollywood Café was long past.

Eating in the Suburbs

The Lost Restaurants of Central El Paso

JOSEPH LONGO WITH ROBERT DIAZ

Central El Paso is home to some of the city's oldest suburbs and some of its most famous "lost restaurants." The area is sprawling, including neighborhoods such as Sunset Heights and Kern Place on its west side and Five Points and Alamo Heights on its east side. Longtime residents often engage in lively debates about where the boundaries of this massive district begin and end. Indeed, as the city has grown, central El Paso's informal perimeters have expanded and changed. Suffice it to say that despite its malleable perimeter, "Central"—as locals call it—has been home to an abundance of fanciful restaurants serving delectable cuisine and memorable experiences. To examine the culinary history of this area of El Paso, one need only to comprehend the stories of the iconic restaurants that once captured the hearts and souls of El Pasoans. This chapter, though by no means comprehensive, will highlight several of the most noteworthy eateries open in Central during the twentieth century.

SUNSET HEIGHTS AND KERN PLACE

Sunset Heights was not originally part of central El Paso; instead, it was one of the city's first suburbs north of downtown. It emerged after the railroads led to an exponential increase of El Paso's population. Indeed:

Southern Pacific Depot looking northwest. You can see Mesa Garden on top of a hill in Sunset Heights in the background, circa late 1880s. *El Paso County Historical Society.*

Sunset Heights is the product of El Paso's economic successes and population boom which began in 1881. When the first railroads arrived in May of that year, approximately 1,000 people lived in present day downtown. Within ten years, the population rose to approximately 10,000. Because of the population increase, New Yorker J. Fisher Satterthwaite mapped and developed an eponymous subdivision in the rolling hills north of the city center between 1883 and 1884.[172]

The idea that El Paso's residents would venture so far north from the city center was laughable to many people. Nevertheless, commercial interests infused capital into this desert landscape. A contest was even held by one of the local newspapers, encouraging residents to submit potential names for the area. In December 1899, the El Paso Commercial Company chose "Sunset Heights," which had been sent in by four individuals who won $50 for their entry.[173]

One of the first venues built for food and entertainment in Sunset Heights was a beer garden owned by Satterthwaite himself. Known as Mesa Garden, it once stood on a hill overlooking downtown. The complex consisted of two houses, a main pavilion and two small buildings. A kitchen, dining hall and horse shed were later added. Mesa Garden was also home to the McGinty Club, a social group whose fantastic firework shows could be viewed from downtown. Soon, the restaurant and bar became a gathering place for El

MESA GARDEN,
ON SATTERTHWAITE'S ADDITION
NEAR THE BOULEVARD AND RIO GRANDE ST.

Mesa Garden offered premier entertainment and meals at the turn of the century. *El Paso County Historical Society.*

Pasoans. Visitors could see the Cardiff Giant—a ten-foot stone statue of a man billed as a petrified, prehistoric behemoth. In reality, it was a hoax that captivated imaginations in the mid- to late nineteenth century.[174] Other attractions at Mesa Garden included a menagerie, an ice cream parlor and a carousel.

The heyday of Mesa Garden came to an end at the turn of the century. The McGinty Club left, and the enterprise declined because of poor

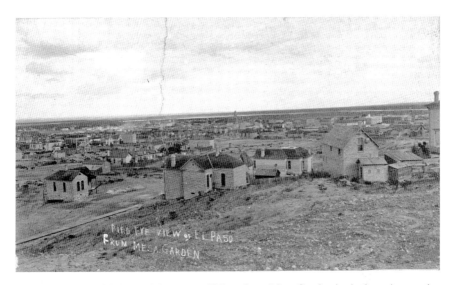

A view of Sunset Heights and downtown El Paso from Mesa Garden in the late nineteenth century. *El Paso County Historical Society.*

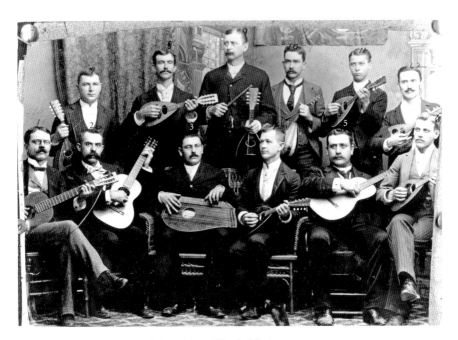

McGinty Band, circa 1900. *El Paso County Historical Society.*

upkeep. The owners grew frustrated, not knowing how to proceed with business operations. In 1911, the remaining buildings at Mesa Garden were demolished to make way for a house built for local attorney and civic leader Richard F. Burges. Today, the Burges House is located in the footprint of Mesa Garden and has a fascinating history of its own. Indeed, the American foursquare home was designated a Texas Historic Landmark in 1993 and has been the headquarters of the El Paso County Historical Society for over three decades.[175]

On a mesa about a mile and a half northeast of Sunset Heights is an affluent neighborhood known as Kern Place. Peter E. Kern, an Ohioan who lived in El Paso in the late nineteenth and early twentieth centuries, envisioned this naturalesque neighborhood to reflect his desire to bring regality and mysticism to the region.[176] It was in this area of El Paso that another iconic local restaurant, Casa Jurado, opened in 1972. This establishment was founded by Estella Jurado, a trained gourmet cook. After years of running a catering business from her home in Sunset Heights, Estella decided it was time to fulfill a longtime ambition: opening a business with her sons Henry and David Jurado. Before informing her family of her intentions to build a brick-and-mortar restaurant, however, she selected the building at 226 Cincinnati Avenue, near the University of Texas at El Paso, and placed a deposit on it.

The management of the restaurant was a family affair. While Henry and David focused on business matters, Estella supervised the kitchen. It was Estella's recipes for Mexican food that made the restaurant a success.

The Burges House, headquarters of the El Paso County Historical Society, is located on land formerly occupied by Mesa Garden. *El Paso County Historical Society.*

Kern Place, a suburb in the western portion of central El Paso. *El Paso County Historical Society.*

She learned how to make these recipes in cooking classes and from her grandmother in Juárez. One of Casa Jurado's specialties was "enchiladas norteñas"—enchiladas with dark red chile sauce that were stacked instead of rolled. Another specialty was salpicon—a salad of shredded, marinated beef served cold. In 2000, Michael Nosenzo of the *El Paso Times* wrote: "But it is certainly the food that is the decisive factor in the restaurant's success, beginning with crisp tosadas and a superior chile de arbol salsa, full of complex flavors but without the intense fire sometimes displayed by that particular chile. It did possess a robust heat, certainly enough to get your attention, but not so much as to kill your taste buds."[177] The establishment was also famous for its creamy chile con queso and its sweet mole sauce.

For nearly fifty years, the Jurado family offered El Pasoans a delicious array of Mexican food. The restaurant was so successful that the Jurados opened a second location in 1984 at 4772 Doniphan in west El Paso. For the next two decades, the original Casa Jurado continued to thrive in Kern Place as well. After Estellas's death in 1981, David and his wife took over business operations. In 2004, however, they sold the Kern Place location, which, under new management, stayed open until 2010. Seven years later, the Doniphan location also closed its doors. Though Casa Jurado is now, unfortunately, one of El Paso's lost restaurants, its cuisine remains at the forefront of El Pasoans' minds, and its legacy will continue to live on.[178]

FIVE POINTS

Just a few miles east of Kern Place lies Five Points, a historic commercial district. Like Sunset Heights, the Five Points area was desolate in the late nineteenth century, consisting mostly of desert shrubs, dirt and rocks. By the early decades of the twentieth century, however, El Paso had annexed much of the land in this suburb, and some entrepreneurial residents opened businesses along its newly paved streets.[179] A group of businessmen at a dinner in 1917 gave the district its name, selecting "Five Points" because "the location of the places of business are at a point where Montana Street, Elm Street, Piedras Street, and East Boulevard all meet."[180] The magnates at this dinner hoped to "make known to all the central portion of the city that there is…a group of up-to-date business undertakings which warrant trading there, thus eliminating time and carfare spent in making downtown purchases."[181] Restaurants thrived in Five Points, including Ashley's Mexican Restaurant, Gillespie's Steakhouse, the Empire Club and Oasis Restaurant.

Ashley's Mexican Restaurant had its roots in a milk bar opened by George Ashley in 1931. Located at 2864 Pershing Drive, the building Ashley purchased for his enterprise was near his parents' house and abundant vehicle traffic. Ida Ashley, his business-minded mother, who had been successful in California real estate, was his sole investor. George Ashley opened his first restaurant with only one table and several chairs. Initial earnings were meager. To boost sales, he started offering Mexican

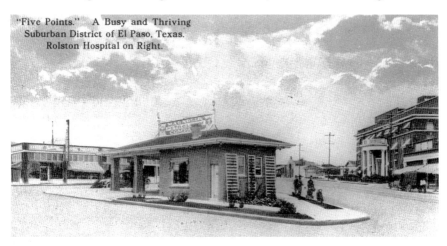

Five Points Business District, circa 1920. *El Paso County Historical Society.*

102

Interior of Ashley's Gardens in the 1960s. This location was a few miles east of the original Five Points restaurant. *El Paso Historical Society.*

food based on his mother-in-law's recipes. In 1935, he named the establishment Ashley's Mexican Restaurant. The Ashley brand eventually included the restaurant and Ashley Inc., a canning and freeze-dried food operation. Ashley Inc. became a multimillion-dollar company, shipping more than six million cans and packages of Mexican food products all over the world, including Japan, Scandinavia and Australia. In 1937, George Ashley was one of the first people to can tortillas, and at one time his company supplied tortillas to half of the El Paso retail market. In 1957, a restaurant called Ashley's Five Points Gardens was opened next to the plant at 6590 Montana Avenue. But by the 1990s, the Ashley brand had become a distant memory in El Paso.[182]

Just a few blocks away from Ashley's Mexican Restaurant, a hungry El Pasoan could eat at the Oasis. Fred Hervey (not to be mistaken for Fred Harvey, namesake of the Harvey Girls restaurants), who later became a successful entrepreneur and mayor of El Paso, opened the first Oasis Restaurant in 1930 at the intersection of Birch and Montana. Hervey made his entrance in the food service industry operating a concession stand selling popcorn, soda and ice cream outside of the American Theater at 2806 East Yandell. To open the first Oasis, Hervey and his brother George borrowed $3,000 from contractor H.T. Ponsford. The establishment first sold cold sodas and sandwiches. Hervey later built two more restaurants in

Assembly-line production, and boxes of fresh tortillas roll out of the factory for an ever-increasing local demand.

Workers make fresh tortillas at the Ashley's plant, no date. *El Paso County Historical Society*.

downtown El Paso and, in 1945, opened a drive-in restaurant known as the Oasis Town Pump at 1903 Montana. The Town Pump was one of the city's first drive-ins. As other Hervey-run drive-ins opened around town, some became known for having a van on top of their buildings. Round parking lots also made maneuvering the drive-ins easier. The Oasis Town Pump was considered a top hangout for teens in the 1950s and '60s, and they gave it the nickname "The O.A." Once located throughout El Paso, the drive-ins closed in the 1970s.[183]

For fine dining in central El Paso, one only needed to visit one of Leon Gillespie's establishments. Gillespie's Steakhouse at 2810 Montana, founded in 1946, was initially marketed as a fried chicken eatery. Sometime later, Gillespie decided that he wanted steak to be the centerpiece of his menu. Indeed, his charbroiled steak was a fan favorite. Though he added seafood to his selections, Gillespie and steak were nearly synonymous in central El Paso. In 1963, a fire damaged both the steakhouse and another Gillespie establishment, the Empire Club, on the same block. Both restaurants were

Mountain View Oasis in 1960. This location, at 8500 Dyer in northeast El Paso, was part of the local chain originating in central El Paso. *El Paso Public Library, Border Heritage Section.*

rebuilt at their original locations. In 1968, the newly reconstructed Empire Club was expanded to include the Red Room, a site for private banquets and additional room for dining. The following year, he opened the Green Room as a dinner theater. Gillespie added an exclusive discotheque known as the Calico Room to the Empire Club in 1975. Though one had to be a member to enter, on occasion, nonmembers could reserve the room for events. During the day, the Calico Room served fast food, but at night, it was a hot spot for dancing and socializing. Gillespie pampered Empire Club members on his private airplane, which took them around the world. He was often joined by his wife, Tommie, on these trips. A trained nurse, Tommie later managed the Empire Club and the steakhouse, developed menus and oversaw catering projects. Gillespie also dedicated himself to eclectic food service. He catered for the cast of the movie *Giant* when they filmed in Marfa, Texas, and provided food and beverages to people at Washington Park, Ascarate Park and the El Paso County Coliseum. In addition, Gillespie founded the Wyoming Inn, Gillespie's Chicken House

and the Yandell Inn, each within about a mile of each other. After Leon Gillespie's death in 1983, Tommie ran the steakhouse and the Empire Club until both closed in 1984.[184]

The suburbs of central El Paso provided patrons with delicious meals, unique venues, and lively entertainment for decades. Though Sunset Heights and Five Points experienced decline during the 1980s and '90s, over the last two decades, these neighborhoods have experienced revitalization spawned by El Pasoans who appreciate their history and relish patronizing local businesses. New restaurants have emerged in Sunset Heights, outside of Kern Place and in Five Points, providing El Pasoans with a diverse selection of meals. These businesses continue the legacy of great dining in central El Paso.

9

Jaxon's, the Other Brother and the Stanton Room

JOE LEWELS

Many longtime El Paso residents have fond memories of the chain of Jaxon's restaurants, which were some of the city's favorite gathering places for lunch, dinner and happy hours from the early 1970s to the early 2000s. The chain's mastermind was Jack Maxon, whose only restaurant experience before he founded Jaxon's at the age of 27 was a summer waiting tables in Dallas while attending Southern Methodist University (SMU) and a stint as a waiter at Miguel's Steaks and Spirits in downtown El Paso from 1969 to 1971. As you may recall from chapter 2, Miguel's restaurant chain was owned by Mike Daeuble, who Maxon called a "life-long friend." Both graduated from El Paso High School in 1963 and attended the University of Colorado in Boulder. Maxon transferred to SMU after his freshman year, thinking at the time that he might go to law school.[185] Like many El Pasoans who leave, Maxon was drawn back to his hometown, deciding that the practice of law was not for him. The borderland's allure does that to people, particularly those with deep roots here. Maxon's family arrived in El Paso in the early 1900s. His maternal grandfather, Dr. J.H. Gambrell, was a general surgeon, while his paternal grandfather, Earl Maxon, found work tending horses that pulled funeral hearses in those days. Jack's father, Howard Maxon, ended up owning and operating the Kaster and Maxon Funeral Home for many years. His mother, Orell Gambrell Maxon, earned a master's degree in political science from SMU and raised three boys, Jim, Jack and Earl.

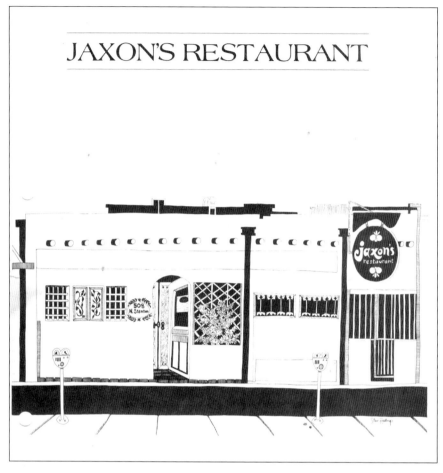

Jaxon's Restaurant opened its doors in 1973 at 508 North Stanton Street in downtown El Paso. *Jack Maxon.*

Clearly, Maxon's deep roots in El Paso and a family history of hard work and achievements gave him the confidence he needed to find his own success. But how? Maxon said in a 2019 interview: "[I] never planned to be in the restaurant business. If I had been inclined that way, I would have studied restaurant management. I would have been way ahead of the learning curve on restaurant operations. Instead, I had to learn the hard way—on the job." Maxon enjoyed working in restaurants, so in 1972 he decided to open his own. He found a downtown building at 508 North Stanton that had once been a beauty shop on one side and a bookshop on the other. "It didn't look like much, but I thought I could make it into

my dream place," he said. He visualized a restaurant that served creative soups, salads and sandwiches, and also had a good bar. "John Kemp, the owner of the building, took a chance on me and I signed a five-year lease with two five-year options," he added.

GETTING STARTED

Maxon first realized that it would take capital to pay for total remodeling of the old building. "I financed the project with a small amount of money I inherited from my father, who died in 1958, and a bank loan from the State National Bank that had to be guaranteed by my mother, as I had no business credit track record," he explained. "I was my own contractor and I oversaw all the remodeling. I hired all the subcontractors for electrical and plumbing; and I hired an all-around construction guy named Antonio Macias, who could do anything!" Maxon recalled he had a general idea of the layout he wanted, but he needed help to get the kitchen just right. He relied on his friend Bruce Gulbas and Bruce's father, Irving, who owned National Restaurant Supply Company, and their employee, Frank Rueda, to design and equip that area of the building. Then he hired some part-time carpenters to build the bar, ceilings, tables and booths out of recycled lumber from old railroad cars he found at McKinney Wrecking. The old wood gave the restaurant the warm, friendly ambiance he sought. In some places, Maxon peeled off the plaster on the walls and left the brick exposed for aesthetic effect. Then he installed an oak floor in the bar and dining room and quarry tile in the kitchen.

The establishment was taking shape, but Maxon needed training to learn how to run a restaurant. For that, he traveled to Annandale, Virginia, to work with Bob Wills, who owned a chain of restaurants called the Three Chefs. Maxon explained that "Bob gave me his cumulative knowledge in a whirlwind course in restaurant management. I was overwhelmed, but I felt I could continue to learn on the job back home because money was running low and I had to get the restaurant opened and generate cash flow to pay off my mounting bills." Maxon's staff quickly tested all the menu items by committee, with Maxon having the final say on which recipes to use. At first, he did not think he needed a hamburger on the menu, but he decided at the last minute to add one: a green-chile cheeseburger served with beans and fruit. "It became our best seller from day one, along with our 'Chavo,'

which was a grilled chicken breast sandwich with avocado, green chiles, and melted cheese on a toasted Kaiser roll," he recalled. "I hired mostly co-eds from the University of Texas at El Paso as waitresses even if they had little or no experience. They had good personalities and great attitudes. They were quick learners and did a good job." The kitchen was led by Jack Bracy at the opening, and the dishwasher was Oscar Barraza, whom Maxon described as "one of the finest men I have ever known. He worked two jobs to put his kids through college and they all attended UTEP and became successful electrical and mechanical engineers."

The name for the restaurant was suggested by another El Paso High classmate and good friend, Mac Belk. Maxon had agonized to come up with a name, but it was Belk who had the idea of taking the "M" from "Maxon" and replacing it with the "J" from "Jack," creating "Jaxon's." Finally, Gayle Goodwin, Maxon's wife at the time, who had a degree in graphic design from the University of Arizona, designed the logo and the menus. Jaxon's opened its doors in 1973. "I remember distinctly that there was a line outside the door before the 11:00 a.m. opening time and that I had a multitude of butterflies in my stomach because I felt I was flying blind in many areas of the business. But ready or not, we opened."

A DOWNTOWN INSTITUTION

The first day was a disaster, according to Maxon. He spent most of it in the kitchen trying to get the food out on time. Despite the mistakes, the staff did their very best. He ended up buying a lot of lunches the first week. Thankfully, the public, mostly downtown businesspeople, were understanding and gave the team a chance to develop. As the operation and the food steadily improved, Jaxon's quickly became a downtown lunchtime institution. Nevertheless, Maxon found his greatest challenge was getting people to come downtown for dinner and drinks. Once the downtown workforce went home, they tended to stay there. The exception to this pattern was Friday nights after work, when the crowds would come in for happy hour and stay for hours. Jaxon's became the happy hour of choice for downtown. Maxon stated that "there were times you couldn't get through the door. It was THE place to see and be seen for many years in the 1970s and 1980s." This success gave Maxon the idea of building a patio in the back to hold the crowds. The patio was a hit, so he added live music on Friday nights. Patrons

were entertained by a group called Los Paisanos, featuring several UTEP professors, and another group called Applejack, which included Charlie McDonald, Cleo, John Ruddock and Buddy Winston.

Still, getting people to go downtown for dinner on other nights remained a challenge. The restaurant would have to offer something totally different. Maxon decided to rent the adjacent building and create a different, more elite restaurant known for its prime rib, seafood and Caesar salad bar. He named it the Other Brother in honor of his brother Earl, who had been working at State National Bank and joined him as a partner. Maxon explained that "the restaurant business demands many, many hours from a sole proprietor. Over time, it can become exhausting and very stressful. I needed help even though I had a terrific manager—my friend Tony Krakauskas. Earl is a natural 'people person' and he was a great asset to the business until he left in the 1980s."

By then, Jaxon's had become a gathering place for not only local politicos, but also for celebrities who visited El Paso. On Saturdays, local attorney Travis Johnson hosted a weekly roundtable discussion in the back dining room. He brought in Senator Lloyd Bentsen and Governor John Connelly for lunch on one occasion. Steve McQueen and Ali McGraw also stopped by while filming *The Getaway* in the early 1970s. Warren Oates, who was working on *The Border*, dropped in for meals, too. Maxon recalled "seeing Wilt Chamberlain who was in town to play volleyball against the El Paso/Juarez SOL. His head almost touched the ceiling!" Earl Maxon described the time Leslie Nielsen, of *Airplane!* fame, brought a whoopee cushion to lunch. "He let it rip at the same time one of our cute waitresses was walking by. Nielsen said, 'young lady please excuse yourself!' The whole dining room burst into laughter." Furthermore, James Caan, best known for his role as Sonny in *The Godfather*, came in several times while competing in a rodeo.

THE STANTON ROOM AND BEYOND

The Other Brother did not have success as a nighttime restaurant, so the Maxon brothers teamed up with a friend who had operated Plantation, a restaurant in El Paso's Upper Valley. Mandy Zabriskie was an advertising and printing company executive with a passion for fine cuisine. The brothers encouraged Zabriskie to help start a new restaurant in the space that once housed the Other Brother. (That space continued to be used for lunch at

Jaxon's.) The three thought long and hard about starting another upscale dining establishment that would attract customers to the downtown location and came up with a concept they named the Stanton Room. With Zabriskie as the chef and menu creator, the team redecorated the space to evoke a simple, yet classy, take on European-style restaurants they had visited. The Stanton Room soon became a fine dining establishment for El Paso with Zabriskie, Ed Braden and the Romero brothers in the kitchen and great service out front delivered by Tim Kilpatrick, Cotter White, Bill Saab, Mike Gailey, John Heinlein, Matt Barefoot and Dennis Moore. The Stanton Room was an El Paso favorite for several years, but the downtown location just could not achieve an adequate revenue stream. Ultimately, Maxon realized he had to move to a place that could attract more people and began looking for real estate in the suburbs, while leaving Jaxon's and the Stanton Room open downtown.

In 1983, Jaxon's opened in west El Paso at 4799 North Mesa Street. The building once housed a restaurant called Applegate's Landing. Maxon explained, "I tried to give the building a New Mexico–style territorial look but with a menu that included most of downtown Jaxon's favorite items." He initially called it Jaxon's Territorial House so as not to compete directly with the downtown location. He soon realized that was a mistake, "as it became apparent that our guests became regulars at this location because of the Jaxon's name. When we dropped the add-on name, our sales doubled." Meanwhile, the downtown restaurants continued serving lunch and garnered modest evening business, but not enough to make it worthwhile to keep the doors open. Eventually, Maxon decided it was time to sell and concentrate on his new enterprise. He sold the space to a couple of friends, Susan and Brad Cooper, who renamed the place Cooper's.

The westside Jaxon's was a big success, and Maxon kept tweaking the decor to honor El Paso's cultural heritage. "I decorated the place with photos of old businesses, institutions, and local characters. Mandy Zabriskie spent many long hours at the El Paso Public Library and at Darst Ireland Commercial Photographers combing through old negatives. We covered our walls with these old photos, and I bought three large paintings of southwestern art from artist Lindsey Holt for the bar area. The customers loved it," Maxon said.

With the North Mesa operation running smoothly, Maxon began looking for a location on the east side of town. He came across a building on Airway Boulevard that had been a warehouse with ample parking and access to plenty of traffic. Thus began the saga of Jaxon's on Airway. It took almost

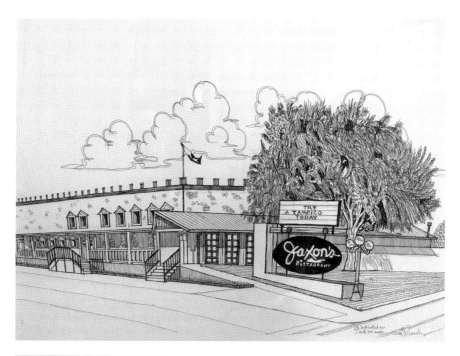

This page: Maxon opened Jaxon's Territorial House (which, later, simply became Jaxon's) in west El Paso in 1983. Its decor and zesty cuisine made it a great success. *Jack Maxon*.

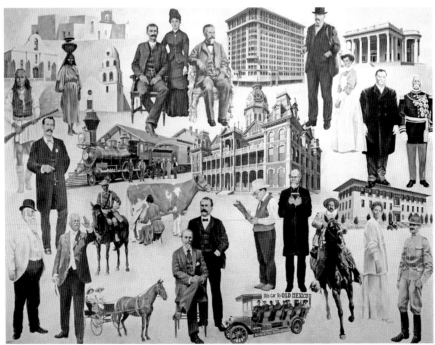

Opposite: These paintings by Bassel Wolfe, highlighting notable people, moments and places in El Paso's history, graced Jaxon's for many years. *El Paso County Historical Society.*

Above: Jaxon's at the corner of Airway and Viscount in east El Paso included the city's first microbrewery and became the highest-grossing restaurant in the group. *Jack Maxon.*

a year to convert the large space into a restaurant and bar, but when it was completed, Maxon decided to call it the Rio Grande Café. That did not work out well, so he renamed it The Headquarters. "Finally," Maxon said, "I got it through my stubborn skull to just name it Jaxon's. I don't know why I didn't just open another Jaxon's in the first place, but I guess I just had a hankering to do something different on the east side of town. The staff would laugh at me and ask me 'What will be the name this week?'" Once they settled on the name and concept, it became the highest-grossing restaurant of the local chain.

Never satisfied, Maxon continued to look for ways to improve on his success. He took several trips a year to study different restaurants in Dallas, Denver, San Francisco and Seattle. He noticed that many successful establishments had in-house brewpubs and thought that El Paso was ripe for one. He built a brewery at the Airway location by constructing a separate structure behind the bar to house the tanks and equipment.

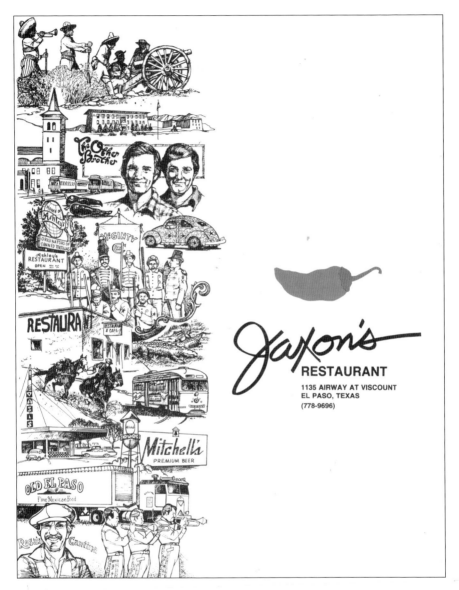

The eastside location's menu featured artwork celebrating El Paso's culinary heritage. Note the homages to Ashley's Restaurant, McGinty Club and Harry Mitchell. *Jack Maxon.*

Since he knew next to nothing about brewing beer, he hired a local amateur brewmaster named John Pilhoefer to set up and run the brewery with the help of his assistant, Don Morrill. "John was a lucky hire, as he made excellent British-style ales and some other types of beer. When

Jack Maxon. *Jack Maxon.*

we first opened, we had large crowds willing to try our variety of home-style beers, which had a more pronounced taste than the light beers and lagers that the El Paso market had always consumed," Maxon explained. The brewery paid for itself quickly, and at first, the restaurant sold only its own brews. Maxon soon learned, however, that many patrons wanted to order Coors or Budweiser to go along with a plate of fajitas or a burger. He realized that he would have to offer common brands to his customers. Nevertheless, Jaxon's brewery entered three of its ales in the Denver Great American Beer Festival and won first place and a gold medal for a beer named Chihuahua Brown Ale. Jaxon's Restaurant and Brewing Company were east side staples in the 1990s.

As 2000 rolled around, Maxon found himself at a crossroads. Both restaurants were doing well, but he felt that he needed to grow or get out of the business. "My concept of Jaxon's was not easily duplicated; additional locations would require large amounts of capital, so I decided to seek a buyer who would take what I had built and expand the concept. I sold the restaurants to someone who had worked at Jaxon's as a waiter and had gone on to become a regional manager for Chili's Restaurants in Idaho. His name was Gary Helsten, and he was someone who knew how to operate a chain of restaurants. Gary did well for a time, but he decided to expand too quickly, and he ended up losing the restaurants," Maxon explained. "It was time for me to move on, and Jaxon's restaurants became an historical dining memory in El Paso."

Clearly, Jack Maxon's upbringing and deep El Paso roots helped him achieve great success as a restaurateur. Besides being a stellar businessman, he has given back to the community that ate at Jaxon's for decades. He served as chairman of the Greater El Paso Chamber of Commerce in the 1990s; he devoted much time to the Boy Scouts of America; he served as president of the downtown Rotary Club; he was chairman of the El Paso Museum of Art Foundation; and he served on the board of directors of the El Paso County Historical Society. Since his youth, Maxon has been a true visionary—willing to pursue new endeavors, adapting to economic changes and always striving for perfection.

PART III

A DOWNRIGHT HOME FEELING

Global Influences on Local Cuisine

Bill Parks Bar-B-Q

Southern Food with a Taste of the Southwest

MEREDITH ABARCA

I first heard about Bill Parks Bar-B-Q from Jake Jacobs during a conversation we had about his memories of first moving to El Paso in 1972 to join the University of Texas at El Paso's (UTEP) track team. Jacobs, an African American from Philadelphia, found in Bill Parks Bar-B-Q a place that connected him to his culinary ancestry. In the early 1970s, the restaurant satisfied his nostalgia for southern-style meals. Jacobs remembers the restaurant not only for its "consistent and excellent" food but also as his "little heaven."[186]

For many years, Bill Parks, an African American retired from the military, owned the only southern-style barbecue in El Paso. It was first located on Piedras and Alameda in south-central El Paso, which was known at one time as the "black and tan" neighborhood. The second location was at 3130 Gateway East, near the interstate.[187] Leona Washington, founder of the McCall Neighborhood Center, an institution celebrating the achievements of El Paso's African American community, states: "This was an older predominantly black part of the community.…Bill Parks was really a landmark in that community. I remember he and his wife Eunice in church always lending a helping hand.…They fed neighbors who were sick. They helped African American students who were in school here at UTEP."[188] Jacobs was one of those African American students Bill and Eunice Parks helped by creating an establishment with a "downright home feeling to it."[189] For many, Bill Parks Bar-B-Q was known as a Texas

landmark. For others, like Jacobs, it was "a home-away-from-home" thanks to its southern-style cooking.[190]

Ultimately, the "downright home feeling" that many patrons experienced at Bill Parks Bar-B-Q stemmed from the global history of barbecue. Indeed, Parks's culinary style reflected traditions born in Africa, the Caribbean and among indigenous peoples in Latin America. It turns out that a "home-away-from-home" is often comforting and inviting because of its complex foundations.

WHO WAS BILL PARKS?

Bill Parks. *University of Texas at El Paso Library, Special Collections Department.*

The man Jacobs remembers as "kind and gentle" was born William Parks in 1925 and raised near Charlotte, North Carolina.[191] As the oldest of six children, he had the privilege of learning to cook from his grandmother and was responsible for helping to feed a large family.[192] He later joined the United States Army, served for twenty years and retired in 1963. While in the army, he worked as an electrician, television announcer and cook. Army cooking did not influence Parks's culinary ability, however. "In the Army," he once said, "you have to follow certain recipes because you're feeding so many people and you have certain nutritional requirements."[193]

Instead, he learned from his family how to cook many items on his menu: "mild-but-rich Southern-style barbecue," black-eyed peas, mixed greens, sweet potato pie, banana pudding and, of course, the smoked meats—chicken, ham, sausage, beef brisket, sliced pork, beef and pork ribs and baby back ribs.[194] What ultimately guided his cooking were the lessons of his grandmother. "I'm a Southerner so I stick to the food that I know," said Parks. "We just try to fix old-fashioned barbecue. What we cook now is what we cooked then" in North Carolina.[195] In his restaurant, he did not follow recipes or worry about nutritional standards. He just made tantalizing sweet and spicy food, what he thought of as "just plain cooking."[196] To him, "most good cooks don't follow a recipe."[197] It is safe to say that his

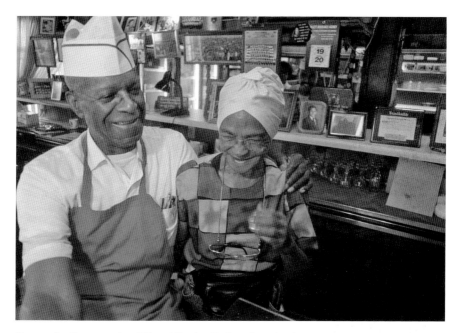

Patrons fondly remember Bill and Eunice Parks, who were the only two people to handle the delicious barbecue at the restaurant. *El Paso Times.*

grandmother taught him to follow his senses and trust his hands while cooking. "My biggest secret is that the same people has handled the food," he said.[198] The only other person who cooked with Parks was his wife, Eunice. She was from Fort Worth and began cooking at age eight or nine. Perhaps it was her touch that led regular customer and attorney Norbert Garney to say, "I'm originally from Houston and I think this is the best authentic Gulf Coast type of barbecue in El Paso."[199]

After retiring from the army, Parks taught electronics at Fort Bliss for a few years, worked for Southwest Airlines and did construction work. His time in construction gave him the opportunity to enter the restaurant business. While working on a building intended to be rented as a restaurant to Reece "Goose" Tatum, formerly of the Harlem Globetrotters, the deal fell through. Parks took the plunge and rented the building himself, which became the site of the first Bill Parks Bar-B-Q. He added a brick pit in the back of the restaurant to smoke and grill his meats. The process infused them with smoky flavors of mesquite, pecan and oak coals. In the late 1970s, the business moved to a new location at 3130 Gateway East, near the interstate.

Parks opened his restaurant in El Paso because he wanted to offer residents an alternative to fast food. "In the past 10 to 12 years," Parks said,

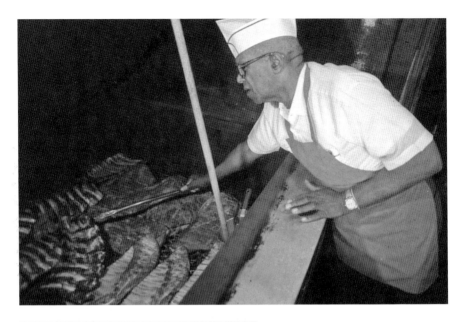

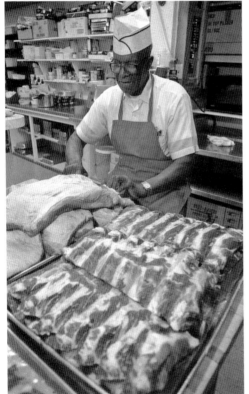

Above: Parks slowly smoked the meats using mesquite, pecan and oak wood. *El Paso Times.*

Left: Parks prepared his cuts of meat before placing them in the smoker. *El Paso Times.*

"most food chains have focused on fast food services—hot dogs, hamburgers, and that's it. People are getting tired of it, let's face it."[200] Smoking meats in an outdoor pit over mesquite-pecan-oak coals is not a culinary technique integral to fast-food establishments, and El Pasoans of all backgrounds relished Parks's carefully smoked meats and sides. It seems that part of the menu's allure for the region's Mexican American community tapped into culinary nostalgia stemming from the global origins of barbecue.

THE GLOBAL ORIGINS OF BARBECUE IN THE SOUTHWEST

Jake Jacobs once told me that the place to go for soul food in El Paso in the 1970s was Bill Parks Bar-B-Q.[201] The concept of soul within the context of African American culture and historical identity arose out of the 1960s and 1970s Black Arts Movement. Soul "was the folk equivalent of black aesthetics....Soul was closely related to Black Americans' need for individual and group identification."[202] In the culinary realm, African Americans associated "soul food" with a shared history of oppression and cultural pride. Soul food was eaten by bondsmen, and it was the food former slaves incorporated into their diet after emancipation. During the 1960s, middle-class African Americans used their reported consumption of soul food to distance themselves from the values of the white middle class, to define themselves ethnically and to align themselves with lower-class African Americans. Irrespective of political affiliation or social class, the definition of "blackness" or "soul" became part of the everyday discourse in the black community.[203] Soul food remained integral to that identity and discourse. Interestingly, Parks did not believe that he cooked soul food. The disagreement between Jacobs and Parks is perhaps not as great as it initially appears, however, because both men addressed that which gives food *soul*: flavors that transcend race, ethnicity, class, time and place.

For over thirty-three years, Bill Parks Bar-B-Q represented a "little heaven" for a number of African Americans in El Paso. While this community has always been relatively small—about 3 percent of the population—its legacy is entrenched in the region. According to historian Quintard Taylor, the African American community in El Paso began in 1752, when "Africans were Spaniards." Taylor's research identifies José Antonio, born in Congo and brought to the Paso Del Norte as a slave, as the first person of African ancestry in the region. After eight years of living in the area, he married an

Apache woman named Marcela. "These Africans and their descendants," says Taylor, "constituted the early El Paso black community."[204] Just like José Antonio, a number of black men married native Mexican women. Through these interactions, cooking techniques and dishes emerged as part of a process of cultural syncretism. Meats were smoked or grilled with *mesquite* wood, pinto beans were cooked in barbecue sauces and cornbread was baked with jalapeño chilies. A century later, Bill Parks's menu reflected this culinary legacy.

The story of José Antonio and Marcela demonstrates the impact of Spanish colonization on New Spain and New Mexico, of which Paso Del Norte was part, between the sixteenth and nineteenth centuries. For three hundred years, indigenous peoples, Spaniards and Africans interacted with each other, at times violently and at other times convivially, in the borderland. Southerners share an analogous history emanating from Spanish and American conquest, most clearly seen in the African slave trade. Chef and food writer Sandra Gutierrez explains that, consequently, Latin Americans and southerners share a historically mixed ethnic makeup and similar culinary traditions. They share the same basic basket of ingredients in their cuisine: corn, cocoa, chili, squash, tomato, sweet potatoes and cassava. They also share similar cooking techniques, such as cooking over an open fire and smoking using wood coals and leaves. To illustrate this last point, Gutierrez speaks of the most iconic southern dish that African Americas have perfected, barbecue, which in turn grew out of *barbacoa*.

Barbacoa is a word, an entrée and a style of cooking that eludes easy explanation. To highlight this point, Marvin C. Bendele begins his article, "Barbacoa? The Curious Case of a Word," offering a description of eating barbacoa tacos in an East Austin, Texas restaurant. The corn tortilla tacos were filled with shredded beef that came from a cow's cheek. As he reminisced about the origin of the word *barbacoa* and its connection to Texas barbecue, he asked: "Is this barbacoa barbecue, or for that matter, is this barbacoa even barbacoa?"[205] The answer to this question lies in a culinary history not often addressed or even recognized when one speaks about, reads of or savors barbecue in the United States.

Much has been debated about the origin and authenticity of barbecue without acknowledging *barbacoa* as barbecue's etymological origin. The word is Spanish, with its root in the Arawak word *barbaca*.[206] By stressing the linguistic link between *barbacoa* and *barbecue*, the culinary contributions of indigenous peoples of the Caribbean and Mesoamerica (as well as South America) to southern-style barbecue become clearer. The Arawak word

barbaca changed with the arrival of Spaniards to the Caribbean. Thus, *barbaca* became *barbacoa*, the word first appearing in print in 1565 and described as a physical raised wooden structure with a grill-like frame on top. Here meat was placed and cooked through a slow process of smoking and steaming through direct flames. Over the years, the definition of *barbacoa* expanded to include another culinary technique: pit cooking. *Barbacoa* thus encompasses two methods of cooking meat: direct open flame and indirect steam produced from coal cooking. Traditional *barbacoa* in northern Mexico and the southwestern United States "involves digging a three-foot-by-three-foot pozo, or hole....The next step is to line the bottom and sides...with rocks before covering the rocks with mesquite wood, starting a fire, and letting the wood burn to hot coals....[Then] the cook places maguey leaves over the coals before putting the prepared meat into the hole."[207] (The meat is also wrapped in maguey leaves before it is placed inside.) Once meat is placed in the *pozo*, a piece of tin is often used to cover the hole before adding dirt to seal it. The meat is then smoked for twelve to fourteen hours. This same process, with different meats, different woods and leaves to wrap the meat is practiced in other parts of Mexico. In central Mexico, Sonora and Chihuahua, it is known as *birria*, and the preferred meat is lamb; in Veracruz, it is called *cochinita pibil*, where either an entire hog or parts of it are buried.

The evolution of *barbacoa* cooking from using open direct fire to indirect heat created by coals and moisture produced from the leaves and soil links this method with that of other Amerindian practices. Aztecs, Mayans and Incas all cooked meats in pits. The Aztecs used the Nahuatl word *tlatemati* to describe cooking from within the earth; the Spanish word *tatemar*, to roast with open flames, comes from this Nahuatl word. The Mayan word *pibil* means "buried or cooked underground." The Quechua word to speak of this process of cooking is *pachamanca*, where the prefix *pacha* means "mother earth." All of these practices place a symbolic meaning to cooking in a pit: the womb of the earth literally cooks that which nourishes us.

Often, the contributions of Africans to the evolution of barbecue have also been overlooked. *Barbecue* not only derives etymologically from *barbacoa* but also from *babbake*, a complex West African word used among the Hausa people referring to "grilling, toasting, building a large fire...cooking food over a long period of time over an [open] fire." The Hausa people also ate *killishi*, roasted meat basted in oil, herbs and spices.[208] Food historian, chef and blogger Michael W. Twitty notes this oversight by stating that while barbecue is "as African as it is Native American and European...enslaved Africans have largely been erased from the modern story of American

barbecue. [Yet they have] shaped the culture of New World barbecuing traditions, from jerking in Jamaica to *anticuchos* in Peru to cooking traditions in the colonial Pampas [of Argentina]."[209] Texan food writer Robb Walsh reflects on why African American and Native American influence is not always acknowledged, stating: "When I started writing…*Legends of Texas Barbecue Cookbook*, I believed that Texas barbecue was invented by German butchers in meat markets.…But there were a few problems with the genesis story. For one thing, 'barbecue' isn't a German word or a German concept."[210] Perhaps this inaccurate history emanates from insidious reasoning. Claiming Texas barbecue is a German creation avoids discussions of Texas's role in perpetuating slavery and in the Confederacy, "emphasizing instead its cowboy tradition."[211] Stated another way, African and African American contributions to the history of barbecue may have been downplayed to prevent "confronting some uncomfortable truths." "But," as Walsh states, "if we [continue] to avoid the subject, the contribution of African Americans will never be fully recognized."[212]

GLOBAL FLAVORS AT A HOME AWAY FROM HOME

Eating involves a process of remembering. When patrons ate at Bill Parks Bar-B-Q, they often connected their own culturally specific culinary heritage to the meals that Parks served them. The similarities found within *barbacoa* and barbecue created common palates that linked people who came from different ethnic and racial groups. For Bill Parks, who barbecued and smoked meats in an urban setting in the latter half of the twentieth century, the "womb of the earth" was manifested in the brick pit he constructed outside his restaurant. While Parks's signature offering was his southern-style barbecue, for many of his customers, the food resonated with their own culinary histories.

After three decades of cooking barbeque in El Paso, Parks announced his retirement in May 1998, putting the business up for sale and agreeing to auction off the restaurant equipment. But three months later, with the restaurant not sold and the equipment still in place, he reopened. He explained his return from retirement: "Every time I went out, old customers would stop me, say they missed me and asked when I was going to open again.…When you spend 20 years in the Army and 33 years here, you get used to working. Retirement gets boring. And I missed the

customers."[213] The restaurant, however, did not stay open much longer. Bill Parks died in 2004 and Eunice Parks died in 2006. Nevertheless, El Pasoans still remember the scrumptious meals Parks served, many of them most likely unaware of the global history of barbecue. For people like Jake Jacobs, however, the transnational history of barbecue was secondary to the "downright home feeling" and "little heaven" that Bill and Eunice Parks cultivated over three decades.

11

A Taste of History

Griggs Restaurant

GUILLERMINA GINA NUÑEZ-MCHIRI, CARLOS VÁSQUEZ AND
CLAUDIA RIVERS

Panza Llena, Corazon Contento
Full Stomach, Happy Heart
—*Popular Mexican proverb quoted in* A Family Affair: A Few Favorite
Recipes of Mrs. Griggs

Walking into Griggs Restaurant meant entering a museum, antiques store and eatery all at once. Originally located at 5800 Doniphan Drive in west El Paso, Griggs Restaurant served "New Mexican style" Mexican food. The establishment was part of a small, family-owned culinary empire in the American Southwest. "When Josephine Chavez and Gustave Griggs were united in marriage, two well-known pioneer families of Mesilla joined forces. Four children blessed this union, Katherine, Edgar, Mary, and Consuelo," wrote Josephine Griggs in her cookbook *A Family Affair: A Few Favorite Recipes of Mrs. Griggs.*[214] All four of the Griggs children went on to own restaurants: Katherine and her family operated La Posta in Mesilla, New Mexico; Mary ran La Posta de Rancho Cordova in Cordova, California; Consuelo, her husband, and six children oversaw El Pinto in Albuquerque, New Mexico; and Edgar and his wife, Rita, managed Griggs in El Paso, Texas.[215] Over the course of the twentieth and twenty-first centuries, the Griggs family passed their culinary traditions on to their children, employees and customers. Though Griggs Restaurant closed

several years ago, the family's recipes are part of El Paso's gastronomical traditions. This is the story of a lost branch of the family's empire—Griggs Restaurant—and the Griggs family's legacy in the borderland.

Edgar and Rita Griggs first opened Griggs Restaurant along Doniphan Drive in 1954. Edgar grew up in Las Cruces, New Mexico, and his mother Josephine inspired many of the dishes at Griggs. The food served has been described as "Spanish" and "New Mexican."[216] This distinction can be hard to define. Perhaps El Farolito Bed and Breakfast in Santa Fe, New Mexico, puts it best: "There are no hard and fast rules for the exact difference between Mexican and New Mexican food, but the distinction is mostly based on the flavor and ingredients used. Many believe that New Mexican food is a fusion between Mexican and Pueblo cooking, with potential influences of Spanish and other Native American cuisines. While it is not exactly Mexican, it is not quite Tex-Mex either; it lies somewhere in between."[217] Roasted green and red chiles are staples of this cuisine, as are other foods found abundantly in New Mexico, such as corn and black beans. New Mexican dishes also tend to feature a red or green chile sauce that is spread atop entrées.[218]

Griggs customers felt at home in the restaurant. Steve Coleman remembers dining at the establishment, which he described as a hacienda-style home with several rooms. The Doniphan Drive location, which Griggs occupied for forty years, gave customers an opportunity to take in the serene nature of El Paso's Upper Valley. It possessed a "spacious entry and patio, filled with tropical plants, [setting] the scene for unhurried, pleasant dining."[219] Coleman recalls visiting the restaurant to enjoy a good meal while watching the birds outside. He also remembers the personal service and hospitality provided by Edgar and Rita and watching the numerous local families who frequented the restaurant after Mass on Sundays.[220]

Edgar and Rita later opened a second location on Montana Avenue in east El Paso, not far from the airport. Inside, visitors could view an old phone booth and piano. Indeed, both locations were packed with all sorts of oddities amassed by George Griggs—a geologist, historian, statistician and Edgar's uncle. George had worked in Chihuahua, Mexico, for many years, bringing artifacts back with him. In addition to items said to have belonged to gunslinger Billy the Kid, and to Maximilian I of Mexico and his wife, Carlotta, George collected antiques and "a sculpture of him in bas relief hang[ed] over the entrance to the museum [on Doniphan] as if keeping watch over these treasures."[221] Moreover, apart from listing their delicious meals, the Griggs menus offered guests more engaging ephemera. They included short selections that customers could read to pass the time as they

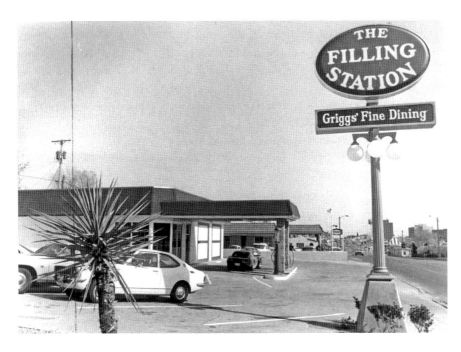

Above: Griggs Restaurant on Montana Avenue. *University of Texas at El Paso Library, Special Collections Department.*

Left: Cover of *A Family Affair: A Few Favorite Recipes of Mrs. Griggs*, published in 1968. *University of Texas at El Paso Library, Special Collections Department.*

waited for their meals. Features on the menus included "Chile Chat," "How to Select a Wine to Go with New Mexican Food," "Billy the Kid," "Which Is Hotter: Red or Green Chile?" and "What Is New Mexican Food?" An image of a ristra of New Mexico red chiles adorned the menus pages.

In the back of the Montana location were two dining rooms with plain glass windows where patrons could sit bathed in sunlight while staring outside. Coleman states, "I liked the sunshine on me during the winter. It was a place you could go and read. It was a special place but of course the food was also very special. Every time I went, Mr. Griggs or his wife was there. They were always supervising and made the sauces. Everything was like it was home cooked with the family's own interpretation of New Mexican food."[222]

Josephine Griggs, Edgar's mother, inspired many of the recipes prepared at Griggs. In 1968, she published, along with Elaine N. Smith, her recipes in *A Family Affair: A Few Favorite Recipes of Mrs. Griggs*. Coleman says that these meals reminded him of the food he grew up eating in Albuquerque, New Mexico, explaining: "Griggs has the best New Mexican style food in town. I like the red and green enchiladas, chiles rellenos, and stuffed sopapillas (I order them with the red chile on enchiladas)." Coleman expands further on the Griggs menu: "The Griggs extended family originated La Posta in Mesilla and El Pinto in Albuquerque, New Mexico. For some reason, though, only this restaurant seems to provide the rich flavors and spiciness that I think accurately represent the original recipes." Interestingly, Coleman also says that one attempting to replicate the meals using the recipes will probably end up with a dish tasting unlike the food served at the family's restaurants.[223]

The recipes for the red and green chile sauces are as follows:

Green Chili Sauce
12 green chilis
2 medium tomatoes
2 small buds of garlic
salt and water

Roast and peel chilis. De-vein and de-seed. Chop the chili fine. Add tomatoes and garlic, salt and enough water to cover. Simmer 10 minutes, add more water as needed.

Red Chili Sauce
12 pods dried chile
2 cups water
1 teaspoon salt
2 tablespoons lard
1 tablespoon flour

Wash chili, remove stems and seeds. Bring chili and water to boil, reduce heat and allow to steam for 10 minutes or longer. Pour liquid into blender or Osterizer, place chili in liquid. If too much skin is left, strain sauce through a colander or sieve. Add salt to taste. Heat lard in frying pan, add flour and brown, pour into chili sauce. Stir until thickened. Add more water for thinning consistency.[224]

Patrons also enjoyed the chile con queso, which was made as follows:

Chili and Cheese Sauce
1 tablespoon lard or bacon drippings
2 tablespoons minced onion
6–8 green chilis, roasted, peeled, de-seeded, chopped
1 large clove garlic
½ pound Velvetta [sic] and
¼ pound Longhorn cheese grated or cubed
⅓ cup thin cream or canned milk

Saute [sic] onions in lard until clarified, add chili, garlic and cheese. When cheese is melted, add ⅓ cup of thin cream or canned milk. Stir until well mixed. DO NOT ALLOW TO BOIL.[225]

Griggs Restaurant had a lasting legacy not only on its patrons but also on its employees. Ricardo Villareal, a successful El Paso businessman, remembers working at the Montana location. He considers his time as a busboy his first real job. He developed his own technique for working efficiently, cleaning tables and clearing plates while walking fast throughout the restaurant. He recalls, "When the owner saw how fast I worked and how efficient I was, he fired the seven other busboys working, and within a month, I was the only one there working."[226] Villareal then took on other tasks at the restaurant, working up to seven days, sixty to seventy hours per week. Later, the Griggs became interested in sending the young man to study

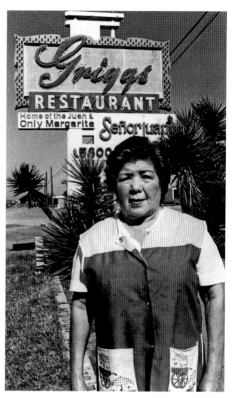

Enchiladas verdes

GREEN ENCHILADAS

1 dozen corn tortillas
2 cups grated cheese
3 cups green chili sauce
½ pint sour cream — on a side dish or on top

Allow 2 to 3 tortillas per person. Fry tortillas in hot fat, immerse in sauce. Place tortilla on plate, sprinkle grated cheese over. Continue this until 3 tortillas per plate are ready. Pour sauce over. Shredded lettuce placed around edge of enchiladas makes a very attractive plate.

Enchiladas coloradas

RED ENCHILADAS

1 dozen corn tortillas
2 cups grated cheese — sharp cheese is better
½ cup chopped onions
2 cups red chili sauce
4 eggs
shredded lettuce

Fry tortillas in hot fat. Leave in only long enough to soften, do not fry crispy. Immerse tortilla in red sauce, leave until well soaked. Place on serving plate and sprinkle generously with cheese and onion. Continue until each plate has 2 or 3 tortillas per person. If tortillas seem dry, spoon additional sauce over all. Fry an egg per person, place on top of enchiladas. Sprinkle lettuce around edge. Enough for 4 people.

Left: Recipes for *enchiladas verdes* and *enchiladas coloradas* included in *A Family Affair*. *University of Texas at El Paso Library, Special Collections Department.*

Right: Employee Alvina Alderete stands in front of Griggs Restaurant on Doniphan Drive in 1985. *University of Texas at El Paso Library, Special Collections Department.*

at Texas Tech University. Villareal credits working at Griggs as one of the best lessons in developing efficiency and dedication in his personal work ethic and entrepreneurship.[227]

Of course, things come to an end. Both Griggs Restaurants closed in the early 2000s, and many members of the Griggs family who ran the culinary empire from California to Texas have passed away. Nevertheless, their food lives on. At Peppe's Restaurant, located at 6761 Doniphan Drive in Canutillo, Texas, Jose "Pepe" Morales and his wife offer Griggs flavors to customers. Morales worked at Griggs for many years, starting at the age of fifteen as a busboy and working his way up to manager. After the Griggs passed away, he inherited the original recipes and opened Peppe's in 2008. Peppe's is also part museum, antiques shop and restaurant, with

Rita Griggs, holding a contemporary menu, and Edgar Griggs, holding a special, one-day menu when the restaurant charged 1954 prices for its twenty-fifth anniversary, November 1979. *University of Texas at El Paso Library, Special Collections Department.*

an ambiance reminiscent of an old American Southwest home. Morales also preserved the Griggs style of presentation, including the way salsa is served in short bottles. He keeps the recipes unique to the region, purchasing ingredients like red chile and sun-dried chiles from local farmers. He maintains the food's integrity by avoiding store-bought ingredients. "Even if you try to replicate the recipes, the chile will not taste the same because the store bought red chile is processed with high heat, and I process my red chile by drying it out in the sun."[228] Out-of-town visitors and locals alike venture to Peppe's to capture a taste of history—a taste of Griggs.

Though Griggs shut its doors years ago, its legacy persists. Indeed, La Posta in Las Cruces still serves visitors, and Peppe's, located along the Texas–New Mexico state line, remains a favorite among locals and out-

of-towners. This is a testament to the power of food and restaurants. A well-regarded restaurant may close, its owners may pass away. But its ambiance, its sights, smells and sounds, the texture and flavors of the food, all live in those who remember these qualities. The legacy of delicious meals, excellent customer service and entrepreneurship still persist within the Griggs family, former employees and customers. Griggs was not only a restaurant. For many, it was also home.

Conclusion

ROBERT DIAZ

When we set out to write this book, the COVID-19 pandemic had not yet swept the globe, and millions had not yet fallen ill or perished. Businesses had not been compelled to curtail operations to stop the spread of this virulent threat. In reflecting on the lost restaurants in this volume, it is difficult not to think about the current establishments that face economic strife related to this unfathomable calamity. Some restaurants will weather the storm. Some, unfortunately, will not.

This is all to say that the "lost restaurants" of a city or town are not mere novelties. They are integral to the development and vitality of a region's cultural fabric. They are sites where memories are created, where palates encounter cuisine with centuries, if not millennia, of history. They are places where budding entrepreneurs hope to define themselves and contribute to the economic success of their town. Restaurants provide a sense of cultural exchange and community. This is all true of the restaurants in El Paso and Ciudad Juárez.

Countless times, El Pasoans have driven through town, noting that one restaurant or another has closed. Shock and melancholy often register from these revelations. For numerous *paseños* restaurants are extensions of the home and office. When a beloved restaurant closes, patrons are only left with memories of rich flavors, friendly staff and colorful ambiance. Conversely, for the proprietors of these businesses, the fortunes of home and checkbook are directly tied to their success.

Today, restauranteurs in El Paso, like people worldwide, struggle to adapt and sacrifice to combat the ravages of this devastating pandemic. Similar to those who lived through World War II, we are obliged to sacrifice for a greater good: the health of our neighbors. Restaurants should stand at the forefront of this effort, demonstrating that they are not simply places to dine but also vital to the preservation of a community's well-being.

We cannot predict how the pandemic will end, nor can we predict the many ways in which our lives and community will be changed. The history of El Paso's eateries, however, has taught us this: the most remarkable restaurants are those that not only serve phenomenal meals but those who also look out for their fellow *paseños*.

Notes

Introduction

1. *Texas Advocate* (Victoria), April 5, 1850.
2. Magoffin, *Down the Santa Fe Trail and into Mexico*, 206.
3. *Directory for the City of El Paso, 1888.*
4. YMCA Ladies' Auxiliary, *El Paso Cook Book*, introduction, 149–65.
5. *Paseño* is a term used to describe a person from the Paso Del Norte region.

Chapter 1

6. Simmons, *Last Conquistador*; Timmons, "El Paso Area in the Mexican Period," 1–2.
7. Sando, *Pueblo Nations.*
8. Kinnard, *Frontiers of New Spain.*
9. T. Henderson, *Glorious Defeat*; Griswold del Castillo, *Treaty of Guadalupe Hidalgo.*
10. Mills, *My Story*, 51.
11. It should be noted, however, that despite frequent references to the borderland's rich agricultural output, volatile changes in climate and droughts also created dire food shortages. Not all people in the borderland had equal access to food either.
12. In Chihuahua, Mexico, El Paso Del Norte retained its name until 1888, when it was renamed Ciudad Juárez, in honor of Mexican president Benito Juárez.
13. Frazer, "Purveyors of Flour to the Army," 220–22.
14. Jones, "Heritage Homes of El Paso," 116.

15. Davis, *El Gringo*. To avoid confusion, it is important to remind readers that two El Pasos existed in the borderland at this time: El Paso Del Norte (present-day Ciudad Juárez in the Mexican state of Chihuahua) and El Paso County, Texas, in the United States.

16. Jones, "Heritage Homes of El Paso," 116–17.

17. Ibid., 117.

18. Ibid., 117–18.

19. Enriqueta López, interviewed by Hilario Hernández Jr., November 27, 1976, tape and transcript no. 258, transcript, El Paso, Texas, Institute of Oral History, University of Texas at El Paso.

20. Brockmoller, "Interview with Mrs. Enriqueta Lopez," 35.

21. Ibid., 39.

22. Ibid., 36.

23. Jones, "Heritage Homes of El Paso," 115.

24. Brockmoller, 3 "Interview with Mrs. Enriqueta Lopez," 8.

25. "La Hacienda Café Offers Authentic Mexican Atmosphere," *El Paso Times*, September 7, 1942

26. Ibid.

27. "Many Soldiers Frequent Hacienda," *El Paso Times*, January 11, 1943.

28. Louise Rea Maxon, "Hacienda Leaves Crowd Drooling," *El Paso Times*, March 31, 1977.

29. Jones, "Heritage Homes of El Paso," 118.

30. *El Paso Herald-Post*, May 19, 1962; "Northeast EP LULAC Council Being Planned," *El Paso Times*, March 17, 1962; "PASO Votes to Support Ordinance," *El Paso Times*, June 14, 1962; "E.P. Demos Form Clubs for Teenagers," *El Paso Herald-Post*, September 17, 1960; "TWC Faculty Plans Dinner," *El Paso Times*, April 20, 1963.

31. "Consul Says Mexico to Stay Democratic," *El Paso Times*, September 16, 1940.

32. "Players Set Act Tryouts," *El Paso Times*, June 15, 1955; "Ft. Bliss Servicemen to See 'Lost Demon,'" *El Paso Herald-Post*, July 29, 1955; "El Paso Players Announce Fall Season's Program," *El Paso Herald-Post*, September 5, 1955.

33. *El Paso-Herald Post*, June 1, 1962.

34. "Show Slated for Bullfight Club," *El Paso Herald-Post*, July 6, 1962.

35. Maxon, "Hacienda Leaves Crowd Drooling."

36. Julius Lowenberg, interviewed by Kristine Navarro, July 28, 2010, transcript no. 1493 (draft), El Paso, Texas, Institute of Oral History, The University of Texas at El Paso.

37. Christina Aguilar, "Landmark La Hacienda Reportedly Closes Doors," *El Paso Times*, March 26, 1998.

38. "Landmark La Hacienda Reportedly Closes Doors," *El Paso Times*, March 26, 1998.

39. Mike Mrkvicka, "La Hacienda: If You Fix It, Will They Come?" *El Paso Inc.*, April 12–18, 1998.
40. Mrkvicka, "La Hacienda."
41. Ibid.

Chapter 2

42. Langston, "Impact of Prohibition on the Mexican–United States Border," 96.
43. Acosta, *Revolutionary Days*.
44. Worthington, *El Paso and the Mexican Revolution*.
45. "Central Café Owner Dies at Age 88," *El Paso Times*, September 24, 1971.
46. Robinson, "Monte Carlo of the Southwest," 95.
47. Ibid.
48. *New York Herald Tribune*, March 8, 1931.
49. Robinson, "Monte Carlo of the Southwest," 94.
50. The word *Don* preceding the name of a man denotes great respect in Mexico and on the border. "Central Café Owner Dies at Age 88," *El Paso Times*, September 24, 1971.
51. "Miss Lee Heads Oasis Follie's Stage Gossip," *El Paso Herald-Post*, June 24, 1922.
52. "Gonzalez to Contest His Deportation," *El Paso Times*, May 10, 1924.
53. *El Paso Times*, June 16, 1922, 9.
54. *El Paso Evening Post*, February 28, 1929, 25.
55. Frank Quartell, interview by Daisy Grunau, March 15, 1977, interview no. 291, transcript, Institute of Oral History, University of Texas at El Paso.
56. Ibid.
57. "El Paso's Finest Place to Dine," *El Paso Herald-Post*, September 24, 1935.
58. Mike Daueble in discussion with the author, May 27, 2019.

Chapter 3

59. Quoted in Lockhart, *Breweries and Beer Bottles*, 245.
60. Ibid., 242.
61. "Death Claims Harry Mitchell, Widely Known EP Resident," *El Paso Times*, May 17, 1971.
62. Langston, "Impact of Prohibition on the Mexican–United States Border," 90.
63. Ibid., 99.
64. *El Paso Herald*, December 24, 1926.
65. Quoted in Lockhart, *Breweries and Beer Bottles*, 246.
66. Harry Mitchell Collection, El Paso County Historical Society.
67. *El Paso Herald-Post*, December 9, 1937.
68. Harry Mitchell Collection, El Paso County Historical Society.

69. "What's on the Menu?," New York Public Library, accessed December 10, 2019, http://menus.nypl.org/menus/decade/1920s.

70. Ibid.

71. I was not able to determine the ingredients of the "Special Fizz." Nonetheless, the typical ingredients of a fizz drink from this time included gin, lemon juice, egg whites and club soda.

72. *El Paso Times*, October 26, 1929, and advertisement, *El Paso Herald*, November 27, 1929.

73. *El Paso Evening Post*, March 31, 1928.

74. For example, see *El Paso Herald-Post*, November 4, 1933.

75. *El Paso Evening Post*, November 19, 1928.

76. *El Paso Times*, June 23, 1928.

77. *El Paso Times*, December 24, 1927.

78. "New York Mayor Makes Hit in El Paso," *El Paso Herald*, July 2, 1928.

79. *El Paso Evening Post*, May 30, 1928.

80. "Young Officer Writes Plane Mex. History," *El Paso Evening Post*, September 3, 1927.

81. "Amelia Earhart Powders Nose, Refuses Cigarettes," *El Paso Evening Post*, September 12, 1928.

82. Ibid.

83. Lockhart, *Breweries and Beer Bottles*, 111.

84. *El Paso Herald-Post*, August 19, 1932.

85. Ibid.

86. *Waxahachie Daily Light*, December 27, 1932.

87. Ibid.

88. Langston, "Impact of Prohibition on the Mexican–United States Border," 112.

89. *El Paso Times*, May 1, 1935.

90. Lockhart, *Breweries and Beer Bottles*, 251.

91. *El Paso Herald-Post*, August 29, 1931.

92. Ibid., August 31, 1931.

93. Ibid., September 21, 1931.

94. *El Paso Times*, September 13, 1931.

95. Lockhart, *Breweries and Beer Bottles*, 250.

96. *El Paso Herald-Post*, September 16, 1931.

97. Langston, "Impact of Prohibition on the Mexican–United States Border," 113.

98. *El Paso Times*, June 8, 1935.

99. Ibid.

100. *El Paso Herald-Post*, June 15, 1935.

101. *El Paso Herald-Post*, June 20, 1935.

102. *El Paso Times*, June 8, 1935.

Chapter 4

103. Neal Templin, "Hungry for Business: Busy Lunch Hour Doesn't Always Mean Success," *El Paso Times*, January 26, 1986.

104. Nancy Rivera, "El Paso: A Steak and Potatoes Town?" *El Paso Times*, June 6, 1981.

105. Jewish, Syrian, Lebanese and African American immigrants created small yet prominent communities that still exist; see Lim, *Porous Borders*.

106. Timmons, "El Paso Area in the Mexican Period," 24–8.

107. Perales, *Smeltertown*, 27.

108. Lorey, *U.S.-Mexican Border in the Twentieth Century*, 69. Lorey states that in 1912, 23,238 Mexicans immigrated into the United States.

109. Farrar, "History of the Chinese in El Paso, Texas," 26. Farrar writes that El Paso's Chinatown was "bounded by South Oregon, St. Louis (present-day Mills), San Antonio, South Stanton, Utah (present-day South Mesa), South El Paso, and Overland Streets," where Chinese immigrants lived, owned and operated many businesses, including laundries, gambling dens, theaters and restaurants.

110. Interview with Leigh W. Osborn by Jo Ann Hovious, 1973, "Interview no. 81," Institute of Oral History, University of Texas at El Paso.

111. "Prominent El Pasoans in Society of 1890s: Dinners, Teas Remembered by Old-Timer," *El Paso Times*, April 29, 1956.

112. "The English Kitchen," *El Paso Times*, August 16, 1894.

113. Guerrero, "Mexican Immigrants' Foodways in El Paso, Texas."

114. Ibid., 227.

115. Ibid., 228.

116. "Celebrating the Silver Jubilee of the Mexico Restaurant," *El Paso Times*, December 17, 1939.

117. Edna Gundersen, "Restaurant Owner Keeps Family Business Cooking," *El Paso Times*, May 13, 1985.

118. Adriana M. Chavez, "Leo's Marks Anniversary in EP," *El Paso Times*, March 25, 2006.

119. "Where's the Steak?," *El Paso Times*, June 28, 1943.

120. "Classified Display," *El Paso Herald-Post* January 9, 1940.

121. "Menu Variety Draws Soldiers to Best Café," *El Paso Times*, April 4, 1943.

122. Nancy Rivera, "El Paso: A Steak and Potatoes Town?" *El Paso Times*, June 21, 1981.

123. Linda Barron, "Branding Iron Grills Great Steak," *El Paso Times*, November 2, 1978.

124. "What's Doing in El Paso and Juarez," *New York Times*, February 19, 1978.

125. "Liquor by Drink Served in E.P.," *El Paso Herald-Post*, June 1, 1971.

126. Dingus, "Texan and the Bottle."

127. Ibid.

128. Neal Templin, "Hungry for Business: Busy Lunch Hour Doesn't Always Mean Success," *El Paso Times*, January 26, 1986.

129. Cooper was named El Paso's 1985 Woman of the Year in Business.

130. Doug DesGeorges, "High Costs Force Closure of Coopers," *El Paso Times*, June 21, 1986.

131. *El Paso Times*, September 20, 1970.

132. "Sol Metzgar's Good Barbecue Brought Fame," *El Paso Times*, January 2, 1987.

Chapter 5

133. Fried, *Appetite for America*, 5–8.

134. Bryant, *History of the Atchison, Topeka and Santa Fe Railway*, 109.

135. Ibid., 114.

136. Fried, "Living History."

137. In 1923, Gable purchased the St. Regis Hotel in El Paso and managed it for nine years. He later became New Mexico's first game and fish warden.

138. Kemps, *Harvey Girls*.

139. "Harvey People to Make Depot Ready," *El Paso Herald*, January 17, 1906.

140. *Albuquerque Morning Journal*, January 25, 1906.

141. *El Paso Herald*, February 28, 1906.

142. "Glimpses of the Past," *El Paso Times*, April 24, 1919.

143. King, "El Paso Harvey House," 125–29.

144. Lillian Mendez Medina, interviewed by Patricia Mendoza, Archives of the Harvey Girls of El Paso, Texas.

145. Aurora Gooch Arriola and Fernando Arriola, interviewed by Ben Arriola, Archives of the Harvey Girls of El Paso, Texas.

146. Kelpie Ann Rainey Hughes, interviewed by Jackie Slaughter and Karen Hoover, Archives of the Harvey Girls of El Paso, Texas.

147. Jose Ornales, interviewed by Pres Dehrkoop, Archives of the Harvey Girls of El Paso, Texas.

Chapter 6

148. The relationship between humans' affinity for sweet foods stems back to at least 8,000 BC. Indeed, the history of sweets encompasses broader histories of class distinction, trade and slavery throughout the world. See "The Bittersweet History of Confectionary," *BBC Bitesize*, n.d., accessed March 1, 2020, https://www.bbc.co.uk/bitesize/articles/zm2q4xs.

149. *El Paso Times*, March 2, 1898.

150. "Change in Ownership of the Rogers Candy Store," *El Paso Herald*, February 4, 1902; "Proceedings to Disbar Lawyer," *El Paso Herald*, September 26, 1902.

151. "Confectionary Store Has Changed Hands," *El Paso Herald*, March 17, 1902; *El Paso Herald*, May 15, 1902; *El Paso Herald*, September 24, 1902.

152. *El Paso Herald*, February 4, 1903; "Nogales Has a $40,000 Blaze," *El Paso Herald*, March 3, 1910.

153. "Big Improvements for Elite Company," *El Paso Herald*, September 13, 1910.

154. "Elite Confectionery in Swell New Home," *El Paso Morning Times*, March 17, 1911.

155. "Store Beautiful Is Place of Real Wonder," *El Paso Herald*, March 17, 1911.

156. On March 10, 1922, three partners incorporated the Elite Chocolate Coated Baseball Company in order to sell Elite's locally famous ice cream nationally. By February 1923, the company was located in New York, the ice cream was now known as Babe Ruth Home Run Baseball, and Babe Ruth was the vice-president of the company. See "Babe Ruth Baseballs Originated in Texas," *Honolulu Star-Bulletin* (Honolulu, Hawaii), June 29, 1923; "Frozen Baseball, El Paso Invented, Proves Popular," *El Paso Times*, May 28, 1922; *News Leader* (Staunton, VA), February 3, 1923; "Circa 1922 Babe Ruth Ice Cream Wrapper—Extraordinary Rarity!," Robert Edward Auctions, n.d., accessed October 11, 2019, https://www.robertedwardauctions.com/auction/2015/fall/1002/circa-1922-babe-ruth-ice-cream-wrapper-extraordinary-rarity.

157. Romo, *Ringside Seat to a Revolution*, 273.

158. "El Paso's Payroll Builders," *El Paso Evening Post*, December 16, 1930; *El Paso Herald*, First Edition. March 5, 1918.

159. *El Paso Herald*, February 4, 1920.

160. "Buckler Building Lessees Ask Hundred Thousand in Damages," *El Paso Times*, July 28, 1925.

161. In April 1968, the building was torn down in order to expand the Empire Club, a private club once located at 2814 Montana Avenue. See chapter 8 for more on the Empire Club, the Five Points neighborhood and its restaurants. "Five Points Building Leased for Confectionery," *El Paso Herald*, April 27, 1923; *El Paso Times*, December 13, 1924.

162. *El Paso Times*, March 1, 1925; "El Paso's Payroll Builders," *El Paso Evening Post*, December 16, 1930; "Ask Receiver," *El Paso Evening Post*, January 20, 1931; *El Paso Evening Post*, February 4, 1931; *El Paso Times*, March 29, 1931; "Joseph Young Dies in Home," *El Paso Times*, April 19, 1931; *Certificate of Death: Joseph Henry Young*, filed April 20, 1931, Texas State Department of Health, Bureau of Vital Statistics, Registrar's No. 564, File No. 18115. Informant: Mrs. J.H. Young, El Paso, Texas.

Chapter 7

163. "Architect Works to Save Historic Downtown Cafe," *El Paso Times*, May 24, 1999; "Remnants of Hollywood's Glitzy Past," *El Paso Times*, October 15, 1989.

164. *El Paso Times*, January 20, 1934.

165. "Cafe Operator Held After Girl's Charge," *El Paso Herald-Post*, August 9, 1934; "El Paso Police Order Girls Out of South End Night Clubs," *El Paso Times*, March 12, 1936; "Night Club Girls Banned," *El Paso Times*, March 12, 1936.

166. "Cabaret Operator Gets Six Months' Jail Term," *El Paso Times*, September 27, 1934.

167. Marble boards seem to have been a version of Pachinko, which resembles a vertical pinball game. Pachinko was invented in Japan in the 1920s for children but became an adult pastime in the 1930s. "Marble Boards Hidden as Police Make Raids," *El Paso Herald-Post*, May 7, 1935; "Raiding Officers Extend Campaign to E.P. Lotteries," *El Paso Times*, December 10, 1939; "Raids Continue, Chief Asserts," *El Paso Herald-Post*, December 11, 1939.

168. Special officers were "commissioned, without city pay, by the chief of police to 'carry a gun and uphold and enforce the law.'" They hired themselves out as security guards for local businesses, such as banks, schools, and private companies; see "El Paso Special Officers Are Colorful, Rugged Men," *El Paso Herald-Post*, January 22, 1944. "Sees Barroom Killing, Then Shoots Man," *El Paso Times*, December 3, 1935; "Dorsey Freed in Gun Case," *El Paso Times*, December 20, 1935; "Special Officer Faces Hearing," *El Paso Herald-Post*, October 7, 1938; "Gets $5 Fine for Displaying Weapon," *El Paso Herald-Post*, October 10, 1938.

169. Smeltertown was a community of American Smelting and Refining Company employees and their families between the late nineteenth century and the 1970s. It was located along the east bank of the Rio Grande, about a mile north from Oñate's Crossing; see Perales, *Smeltertown*; "Red Cross Meets Emergency," *El Paso Times*, November 30, 1940; "E.P. War Fund Donations Sour to $16,930," *El Paso Times*, January 20, 1942; *El Paso Times*, December 6, 1942; "24-Hour Picket Line Planned at Smelter," *El Paso Times*, February 26, 1946.

170. "Three Are Held in Meat Smuggling," *El Paso Herald-Post*, April 22, 1952; "Second EP Restaurant Man Arrested," *El Paso Times*, April 24, 1952; "Cafe Owner Fined $3500 in Smuggling," *El Paso Times*, June 27, 1952; "Convicted in Meat Smuggling," *El Paso Times*, May 25, 1952. Six years later, Judge R.E. Thomason rejected Jabalie's petition for citizenship based on his "bad moral character." Jabalie had numerous run-ins with both the law and the health department over the previous twenty years. Nevertheless, since he had immigrated legally and was married to a U.S. citizen, he was not eligible for deportation. "Immigration Service Battles Cafe Man's Bid for Citizenship," *El Paso Times*, March 11, 1958.

171. "In Celebration of Life, George Haddad," *El Paso Times*, July 2, 2006; "Hollywood Cafe Gets Renovation," *El Paso Times*, April 15, 1992.

Chapter 8

172. Diaz, "Progress and Preservation."

173. "Sunset Heights, A Beautiful Name Chosen for the Satterthwaite Addition," *El Paso Herald*, December 9, 1899.

174. Eschner, "Cardiff Giant Was Just a Big Hoax."

175. Norman Walker, "Mesa Garden Landmark Passing," *El Paso Herald*, August 1, 1911.

176. Diaz, "Only in El Paso, Peter E. Kern & Kern Place."

177. Michael Nosenzo, "Enduring Casa Jurado Remains Top-Notch," *El Paso Times—El Tiempo Supplement*, October 6, 2000.

178. Alicia Medina, "Casa Jurado Restaurant: Mom's Ideas, Cooking Triumph," *El Paso Times*, February 8, 1976; Abarca, "Without Cooking, There Is No Community," 107–25.

179. Jon Eckberg, "Walking Tour of Five Points," May 12, 2018.

180. East Boulevard is now East Yandell Drive. "Future of 'Five Points' Foreseen by Business Men, Forming Commercial Club," *El Paso Morning Times*, September 16, 1917.

181. Ibid.

182. "Newsboy's Dreams Come True: George Ashley Sees Business Become World Renowned," *El Paso Times*, December 6, 1942; "George N. Ashley, "Mexican Food Processor, Manufacturer of Month," *El Paso Times*, August 9, 1953; "George Ashley Dies; Services Are Set Friday," *El Paso Times*, November 11, 1971; "Demands for Ashley's Food Increases," *El Paso Herald Post*, January 17, 1973; Robert Palomares "Mexican Food Firm Tries Comeback," *El Paso Herald Post*, June 27, 1984.

183. Sandra Pierce, "Oasis Symbolized '50s Teen Scene," *El Paso Times*, *Borderlands Magazine*, May 28, 1995.

184. "Empire Club Specially Designed for Families, Out of Town Guests," *El Paso Herald-Post*, June 11, 1974; "Gillespie's Created Culinary Traditions," *El Paso Times*, June 11, 1974.

Chapter 9

185. All the information compiled for this chapter came from interviews conducted by the author with Jack Maxon in October 2019.

Chapter 10

186. Jake Jacobs, interviewed by Meredith Abarca, "A Musician to the Core Who Loves Food," *El Paso Food Voices*, January 4, 2019, https://volt.utep.edu/epfoodvoices.

187. Sonny Lopez, "Neighborhood Loses Landmark Eatery," *El Paso Times*, August 3, 1998.

188. Ibid.

189. Ibid.

190. Ibid.

191. Jacobs, "Musician to the Core."

192. Craig Phelon, "Bill Parks Down-Home Style to His Old-Fashioned Barbecue Café," *El Paso Times*, May 12, 1977; James Bole, "Why Mess with Perfection? Bill Parks Figures," *El Paso Times*, September 9, 1999; Jade Walker, *The Blog of Death*, July 8, 2004, www.blogofdeath.com/2004/07/08/billparks.

193. Phelon, "Bill Parks Down-Home Style."

194. Bole, "Why Mess with Perfection?"

195. Ibid.

196. Ibid.

197. Ibid.

198. Ibid.

199. Ibid.

200. Phelon, "Bill Parks Down-Home Style."

201. Jacobs, "Musician to the Core."

202. L. Henderson, "Ebony Jr! and 'Soul Food'," 81–97.

203. Ibid., 81.

204. Dailey, Smith-McGlynn and Gutierrez Venable, *Images of America: African Americans in EL Paso*, 7.

205. Bendele, "Barbacoa?," 88–90.

206. Arawak was a language spoken by the Taino indigenous peoples who lived in the Caribbean. Sandra Gutierrez, "The New Southern-Latino Movement," interviewed by Todd Schulkin, *Inside Julia's Kitchen Podcast*, https://juliachildfoundation.org/podcast.

207. Bendele, "Barbacoa?," 88–89.

208. McWilliams, *Revolution in Eating*, 34.

209. *Jerking* refers to the use of either a dry-rubbed or wet marinade infused with allspice, which is native to the Caribbean. Meat is then grilled over an open fire while smoky flavor is added by placing leaves in the fire or wrapping the meat with them. Runaway slaves, known as Maroons, perfected this cooking method that they learned from the Taino tribes of Jamaica. *Anticuchos* are seasoned grilled cows' hearts cooked over coals and a meal rooted in the cooking practices of

Afro-Peruvians common to Quechuans. Michael W. Twitty, "Barbecue Is an American Tradition of Enslaved Africans and Native Americans," *Guardian*, July 4, 2015, https://www.theguardian.com.

210. Walsh, *Barbecue Crossroads*, 250.

211. Ibid., 251.

212. Ibid.

213. Mike Mrkvicka, "Bill Parks Serves Barbecue at the Same Place," *El Paso Times*, September 9, 1998.

Chapter 11

214. Mesilla is a small town outside of Las Cruces, New Mexico, about a forty-minute drive northwest from El Paso. Griggs and Smith, *Family Affair*, 1.

215. Coleman, "Griggs Restaurant–El Paso, TX."

216. "New Upper Valley Café Specializes in Spanish Dishes, Seats 100 Persons," *El Paso Herald Post*, January 29, 1955.

217. "What Is New Mexican Food? Your Guide to the Best Eats," *El Farolito Bed and Breakfast*, Santa Fe, New Mexico, accessed July 21, 2020, https://farolito.com/blog/what-is-new-mexican-food.

218. Ibid.

219. Griggs and Smith, *Family Affair*, 3.

220. Coleman, "Griggs Restaurant–El Paso, TX."

221. Griggs and Smith, *Family Affair*, 3.

222. Interview with Steve Coleman by Guillermina Gina Nuñez-Mchiri, October 18, 2019.

223. Coleman, "Griggs Restaurant–El Paso."

224. Griggs and Smith, *Family Affair*, 21 and 35.

225. Ibid, 17.

226. Interview with Ricardo Villarreal by Edmundo Valencia, 2009, "Interview no. 1524," Institute of Oral History, University of Texas at El Paso.

227. Ibid.

228. Interview with Jose "Pepe" Morales by Guillermina Gina Nuñez-Mchiri, Carlos Vázquez and Claudia Rivers, Canutillo, Texas, February 15, 2019.

Bibliography

PRIMARY SOURCES

Collections

El Paso County Historical Society
 Harry Mitchell Collection
 Jon Eckberg Walking Tour of Five Points
 Photographic Collections
El Paso Public Library, Border Heritage Section
Harvey Girls of El Paso Texas, Archives
University of Texas at El Paso, Institute of Oral History
University of Texas at El Paso Library, Special Collections Department
 El Paso Herald-Post Collection, MS348

Newspapers

Albuquerque Morning Journal
El Paso Evening Post
El Paso Herald
El Paso Herald-Post
El Paso Inc.
El Paso Morning Times
El Paso Times
Honolulu Star-Bulletin

News Leader (Staunton, VA)
New York Herald Tribune
New York Times
Texas Advocate (Victoria)
Waxahachie (TX) Daily Light

Books and Articles

Coleman, Steve. "Griggs Restaurant–El Paso, TX." *Steve's Food Blog*. March 30, 2016. Accessed July 20, 2020. http://www.stevesfoodblog.com/blog/griggs-restaurant-el-paso-tx.

Davis, W.W.H. *El Gringo: New Mexico and Her People*. Lincoln, NE: Bison Books, 1982 [1857].

Directory for the City of El Paso, 1888. El Paso, TX: Times Publishing Company, 1888.

Griggs, Josephine C., and Elaine N. Smith. *A Family Affair: A Few Favorite Recipes of Mrs. Griggs*. El Paso, TX: J.C. Griggs & E.N. Smith, 1968.

Jacobs, Jake. Interviewed by Meredith Abarca. "A Musician to the Core Who Loves Food." *El Paso Food Voices*, January 4, 2019. https://volt.utep.edu/epfoodvoices.

Kinnard, Lawrence, ed. *The Frontiers of New Spain: Nicolas De Lafora's Description, 1766–1768*. Berkeley, CA: Quivira Society, 1958.

Magoffin, Susan Shelby. *Down the Santa Fe Trail and into Mexico: The Diary of Susan Shelby Magoffin*. Stella M. Drumm, ed. New Haven, CT: Yale University Press, 1926.

YMCA Ladies' Auxiliary. *El Paso Cook Book, Published by the Ladies' Auxiliary, YMCA*. El Paso, TX: Herald News Company, 1898, Applewood Books.

SECONDARY SOURCES

Abarca, Meredith E. "Without Cooking, There Is No Community: Women Feeding El Paso." In *Grace and Gumption: The Women of El Paso*, edited by Marcia Hatfield Daudistel. Fort Worth: Texas Christian University Press, 2011.

Acosta, Ray Steve. *Revolutionary Days: A Chronology of the Mexican Revolution*. Albuquerque, NM: Editorial Mazatlan, 2010.

Bendele, Marvin C. "Barbacoa? The Curious Case of a Word." In *Republic of Barbecue: Stories Beyond the Brisket*, edited by Elizabeth S.D. Engliherdt. Austin: University of Texas Pres, 2009.

Brockmoller, Janet. "An Interview with Mrs. Enriqueta Lopez as Told to Janet Y. Brockmoller, October 1979." *Password* 37, no. 1 (Spring 1982): 34–40.

Bryant, Keith L. Jr. *History of the Atchison, Topeka and Santa Fe Railway*. New York: Macmillan, 1974.

Dailey, Maceo Crenshaw Jr., Kathryn Smith-McGlynn and Cecilia Gutierrez Venable. *Images of America: African Americans in EL Paso*. Charleston, SC: Arcadia Publishing, 2014.

Diaz, Robert. "Only in El Paso, Peter E. Kern & Kern Place." Interview by Weird Moved West. *Only in El Paso*, KCOS-TV, March 15, 2019. https://www.youtube.com/watch?v=peTE8t1Bilw&t=33s.

———. "Progress and Preservation: A Brief History of Sunset Heights." *City Magazine*, November 2018.

Dingus, Anne. "The Texan and the Bottle: A Brief History." *Texas Monthly*, March 1, 1982. Accessed October 1, 2019. https://www.texasmonthly.com.

Eschner, Kat. "The Cardiff Giant Was Just a Big Hoax." *Smithsonian Magazine*, October 16, 2017. https://www.smithsonianmag.com.

Farrar, Nancy Ellen. "The History of the Chinese in El Paso, Texas: A Case Study of An Urban Immigrant Group in The American West." MA thesis, University of Texas at El Paso, 1970.

Frazer, Robert W. "Purveyors of Flour to the Army: Department of New Mexico, 1849–1861." *New Mexico Historical Review* 47, no. 3 (1972): 213–38.

Fried, Stephen. *Appetite for America: Fred Harvey and the Business of Civilizing the Wild West—One Meal at a Time*. New York: Bantam Books, 2010.

———. "Living History: How Santa Fe Became the Capital of Fred Harvey, the Harvey Girls, and the History of Civilizing the Southwest." *Santa Fe Reporter*, August 2, 2013. https://www.sfreporter.com.

Garcia, Mario T. *Desert Immigrants: The Mexicans of El Paso, 1880–1920*. New Haven, CT: Yale University Press, 1981.

Griswold del Castillo, Richard. *The Treaty of Guadalupe Hidalgo: A Legacy of Conflict*. Norman: University of Oklahoma Press, 1990.

Guerrero, Juan Manuel Mendoza. "Mexican Immigrants' Foodways in El Paso, Texas, 1880–1960s: Identity, Nationalism, and Community." PhD diss., University of Texas at El Paso, 2012.

Gutierrez, Sandra. "The New Southern-Latino Movement." Interviewed by Todd Schulkin. *Inside Julia's Kitchen Podcast*. https://juliachildfoundation.org/podcast.

Henderson, Loretta. "Ebony Jr! and 'Soul Food': The Construction of Middle-Class African American Identity through the Use of Traditional Southern Foodways." *MELUS* 32, no. 2 (2007): 81–97.

Henderson, Timothy J. *A Glorious Defeat: Mexico and its War with the United States*. New York: Hill and Wang, 2007.

Jones, Harriot Howze. "Heritage Homes of El Paso: Hart's Mill—Hacienda Café." *Password* 26, no. 3 (Fall 1976): 115–18.

Kemps, Lesley Poling. *Harvey Girls: Women Who Opened the West*. Cambridge, MA: Da Capo Press, 2013.

King, Patsy Crow. "The El Paso Harvey House." *Password* 51, no. 3 (Fall 2006): 125–29

Langston, Edward Lonnie. "The Impact of Prohibition on the Mexican–United States Border: The El Paso-Ciudad Juarez Case." PhD diss., Texas Tech University, 1974.

Lim, Julian. *Porous Borders: Multiracial Migrations and the Law in the U.S.-Mexico Borderlands*. Chapel Hill: University of North Carolina Press, 2017.

Lockhart, Bill. *Breweries and Beer Bottles at El Paso, Texas*. Morrisville, NC: Lulu Press, 2013.

Lorey, David E. *The U.S.-Mexican Border in the Twentieth Century*. Wilmington: Scholarly Resources, 1999.

McWilliams, James E. *A Revolution in Eating: How the Quest for Food Shaped America*. New York: Columbia University Press, 2005.

Mills, Anson. *My Story*. Washington, D.C.: Anson Mills and Byron S. Adams, 1918.

Perales, Monica. *Smeltertown: Making and Remembering a Southwest Border Community*. Chapel Hill: University of North Carolina Press, 2010.

Robinson, Robin Espy. "Monte Carlo of the Southwest: A Reinterpretation of United States Prohibition's Impact on Ciudad Juarez." MA thesis, University of Texas at Arlington, 1997.

Romo, David Dorado. *Ringside Seat to a Revolution: An Underground Cultural History of El Paso and Juárez*. El Paso, TX: Cinco Puntos Press, 2005.

Sando, Joe S. *Pueblo Nations: Eight Centuries of Pueblo Indian History*. Santa Fe, NM: Clear Light Publishers, 1992.

Simmons, Marc. *The Last Conquistador: Juan de Oñate and the Settling of the Far Southeast*. Norman: University of Oklahoma Press, 1991.

Timmons, W.H. "The El Paso Area in the Mexican Period, 1821–1848," *Southwestern Historical Quarterly* 84, no. 1 (July 1980): 1–28.

Twitty, Michael W. "Barbecue Is an American Tradition of Enslaved Africans and Native Americans." *Guardian*, July 4, 2015. https://www.theguardian.com.

Walker, Jade. *The Blog of Death*. July 8, 2004. www.blogofdeath.com.

Walsh, Robb. *Barbecue Crossroads: Notes & Recipes from a Southern Odyssey*. Austin: University of Texas Press, 2013.

Worthington, Patricia Heasely. *El Paso and the Mexican Revolution*. Charleston, SC: Arcadia Publishing, 2010.

About the Authors

MEREDITH ABARCA teaches Chicana/o literature, Mexican American folklore, major American authors, literature of the Americas, and literary studies at the University of Texas at El Paso (UTEP). She earned her PhD in comparative literature from the University of California at Davis. She is the author of *Voices in the Kitchen: Views of Food and the World from Working-Class Mexican and Mexican American Women*. Her work has appeared in *Food & Foodways* and *Food, Culture & Society*, as well as in edited collections and encyclopedias. She has lectured at the Southern Foodways Alliance Symposium in Oxford, Mississippi, and to MA students in the Food and Communication program housed at the University of Gastronomical Sciences in Parma, Italy.

BRAD CARTWRIGHT serves as the director of the University of Texas at El Paso's Center for History Teaching and Learning, which supports history teacher education and promotes the scholarly teaching of history in all instructional venues. He earned his PhD from the University of Colorado, his MA from the University of Texas at El Paso and his BA from the University of Texas at Austin. His research focuses on race, gender and imperialism in nineteenth-century America and the Pacific Basin. In 2015, he was awarded a University of Texas Regents' Outstanding Teaching Award, and in 2019, he served as president of the El Paso County Historical Society.

PRES DEHRKOOP has dedicated much of her life to civic organizations in El Paso. She has served as chairperson of the Twelve Travelers and the El Paso County Historical Commission, as historian of the El Paso Group and as president of the El Paso Alumnae Panhellenic, the Casa Magoffin

Compañeros and the El Paso Rose Society. She has also worked tirelessly to promote the history of the Harvey Girls. Many El Pasoans may remember Pres as the kind and jovial bridal consultant who worked at Charolette's for many years.

ROBERT DIAZ is a doctoral student in history at the University of Michigan. He earned his MA in history in 2019 and BAs in political science and history in 2013 from the University of Texas at El Paso. He served as president of the El Paso County Historical Society in 2018 and worked on two interpretive exhibits at Chamizal National Memorial as an intern with the Student Conservation Association/AmeriCorps between 2019 and 2020. His current research focuses on the intersections of Spanish and American imperialism and the history of science, medicine and technology in the Pacific world in the nineteenth and twentieth centuries.

MELISSA HUTSON is pursuing her PhD at the University of Texas at El Paso with an emphasis on border history, Mexican film history and the history of theaters along the U.S.-Mexico border. She received her BA in history at the University of Texas at Austin and continued her education at the University of Texas at Austin's Graduate School of Information, where she specialized in digital media and information. In 2020, she served as president of the El Paso County Historical Society.

JOE LEWELS holds a PhD in journalism and mass communication from the University of Missouri, an MS in education from Troy State University and a BA in journalism from Texas Western College (now the University of Texas at El Paso). He was an associate professor and chairman of the Departments of Journalism and Mass Communication at UTEP from 1972 to 1982 and a vice-president and international financial advisor at Merrill Lynch from 1982 to 2013. He served as communications consultant at the U.S. Department of Justice and at the Federal Communications Commission in 1972. He also served in the U.S. Army as a reconnaissance pilot and public information officer for the Seventeenth Combat Aviation Group during the Vietnam War. He was awarded the Bronze Star and Air Medal with oak leaf clusters for his service in combat.

JOSEPH LONGO received his BA in political science, with a minor in museum studies, from the University of Texas at El Paso. He has served as archives chair and curator at the El Paso County Historical Society. His research focuses on the history of politics and gender in El Paso, topics on which he has lectured and published.

GUILLERMINA GINA NÚÑEZ-MCHIRI is director of the Women and Gender Studies Program and an associate professor of anthropology at the University of Texas at El Paso. She received her PhD in cultural anthropology from the University of California Riverside, her MA in Latin American studies and her BA in international business from San Diego State University. She specializes in ethnographic research along the U.S.-Mexico border and has published on topics related to *colonias*, immigration and human rights, housing and social justice, Latina identity, Latinas in STEM fields, immigrant youth and education and the applications of ethnography and service learning in higher education. Her most recent publication addresses women negotiating food insecurity in *colonias* in the Paso Del Norte region. She received a University of Texas Regents' Outstanding Teaching Award in 2012.

KATHY PEPPER is retired from the United States Army and a volunteer at the El Paso County Historical Society. She received her BA from the University of Texas at El Paso. She is an avid researcher with interests in gender studies, the history of women's fashion in El Paso and oral history.

CLAUDIA RIVERS is the head of Special Collections at the University of Texas at El Paso Library. For years she co-edited *Password*, the scholarly journal published by the El Paso County Historical Society. She has also served as president of the Society of Southwest Archivists.

SUSAN STANFIELD is assistant professor of history at the University of Texas at El Paso. She is a scholar of U.S. nineteenth-century history with an emphasis on race and gender as well as political culture. Her research also focuses on U.S. social and cultural history, focusing on reform movements before and after the Civil War as well as food, culture and identity in U.S. history. She earned her PhD in history from the University of Iowa, her MS in communication studies from the University of North Texas, her MA in history from Kansas State University and her BA in history and communication studies from Baylor University. She currently serves on the board of the El Paso County Historical Society.

CARLOS VASQUEZ is an undergraduate student majoring in anthropology at the University of Texas at El Paso. He has worked closely with Guillermina G. Núñez-Mchiri on issues related to the U.S.-Mexico border.

Visit us at
www.historypress.com